THE SPIRIT OF

BMW

50 REASONS WHY WE LOVE THEM

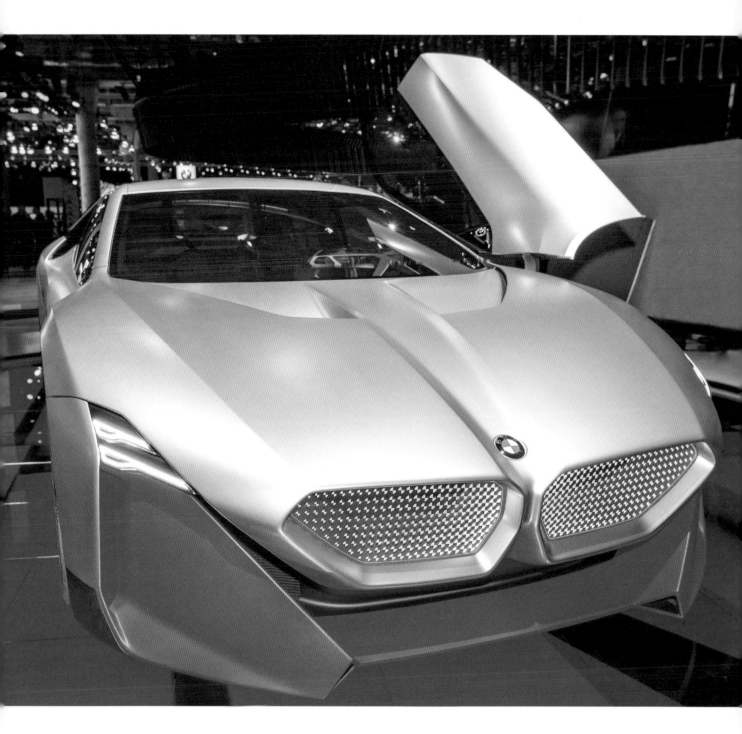

THE SPIRIT OF

BMW

50 REASONS WHY WE LOVE THEM

Vaughan Grylls

BATSFORD

CONTENTS

INTRODUCTION

The Ultimate Driving Machine

This is not a technical book. It is about BMW, a German company that designs superlative cars. These cars entice you into taking for granted how good they actually are, until you drive a car of another make. Then the difference becomes glaring.

Why has BMW climbed to global pre-eminence? Simple. A BMW is a stylish, high-performance automobile that is sporty and easy to drive. Before BMW, high-performance cars could be challenging to master.

When BMW's 3 Series hit the market, its rivals were caught on the back foot. Mercedes had to rethink its legendary construction costs, ponderous design and performance. It was to little avail. BMW would overtake Mercedes in the world's key automobile import market – the USA. A Mercedes may have been classy, but a BMW was fun and young too.

Lesser makes struggled even more. Few today remember the Dolomite Sprint, promoted embarrassingly in the UK by British Leyland's Triumph as 'The BMW Eater'. Not after covering a hundred miles in an hour on a German autobahn it wasn't. Saab and Audi were the nearest European style rivals in the US, yet Saab was a minnow of a company next to BMW, while Audi was just not as sexy and didn't have the model range.

BMW – Bayerische Motoren Werke, or Bavarian Motor Works – was established in 1916 as a manufacturer of aero engines, which it produced from 1917–1918 and then from 1933–1945. In 1928 BMW bought Automobilwerk Eisenach, which held a licence from Austin in

1970s BMW magazine advert.

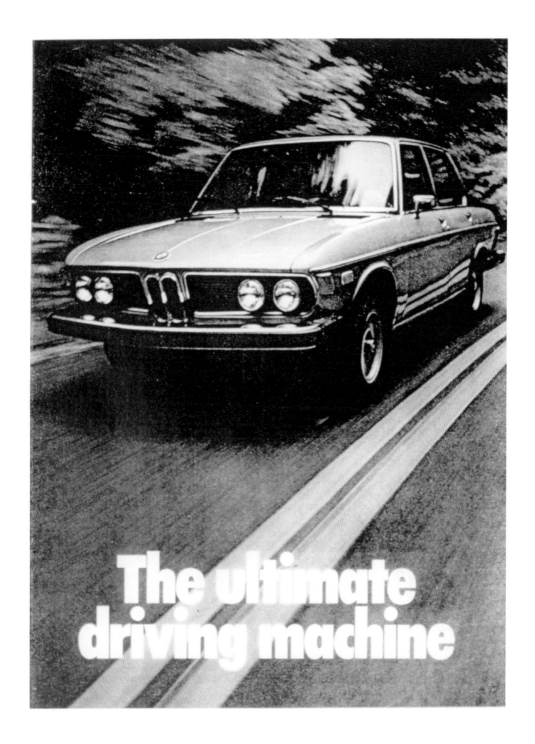

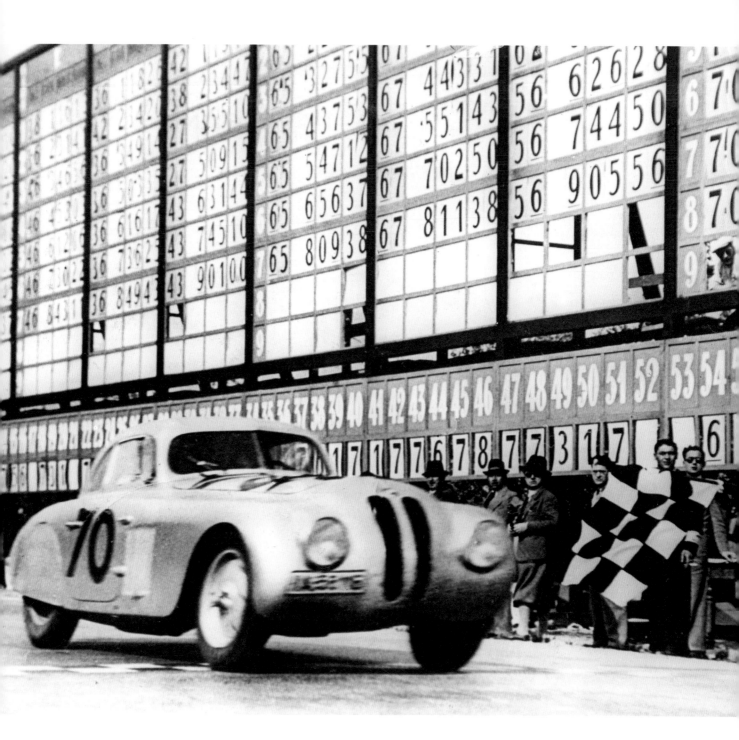

England to build the Austin 7 model known as the Dixi. BMW made some changes and put their badge on it.

Throughout the 1930s, BMW designed their own cars at Eisenach. A particular eye-opener was the 328, a sports model built between 1936 and 1940. Using their impressive 2-litre straight-six, an engine that would become a BMW hallmark, the 328 won important races such as the 1936 Nürburgring Eifelrennen, the 1937 Tourist Trophy, the 1940 Mille Miglia and the 1939 Le Mans 24 Hours race.

In the Second World War, BMW focused on military production, from army motorcycles to the engines for airplanes such as the Dornier bomber. But by the end of the war, BMW's factories lay totally destroyed thanks to British and US air raids.

Like most industrial conglomerates in Nazi Germany, BMW had used slave labour. Although no BMW director or employee has ever been prosecuted for war crimes, at BMW's centenary in 2016 the company issued a statement: 'To this day, the enormous suffering this caused and the fate of many forced labourers remains a matter of the most profound regret.' The mea culpa appeared inadequate.

Above: The BMW Dixi Cabriolet. Opposite: The BMW 328 Mille Miglia Touring Coupé winning the race in Brescia, Italy, 1940.

After 1945 BMW were not allowed to manufacture automobiles because of their involvement in the war, so they produced bicycles and pots and pans to keep the company going. Car production resumed in 1952 with the 501 and then, in 1959, the rear-engined 700. In 1955 BMW introduced the Isetta, a bubble car, built under licence from Iso of Italy and re-engineered by BMW. But by 1959, BMW was teetering on the edge of bankruptcy. It was saved by the German industrialist, Herbert Quandt, who himself had a Nazi past.

From the early 1960s, BMW began to hit its stride as a mass-producer of upmarket, high-performance compact cars. These were the 1500 and 1600 models, leading to the 2000 CS and the 2002ii. BMW had invented a new class of car, pitched between the mass producers and the small-production luxury marques.

It was an opportunity that BMW would capitalize on by launching a numbered series of models – the 5 in 1972, the 3 in 1975, the 6 in 1976 and the 7 in 1978. The motoring celebrity Jeremy Clarkson called these BMWs the same car but in different sizes. This was a little harsh, but in any case these BMWs were German-designed, reliable and fun. They sold like hot cakes throughout Europe and North America – not very surprising when you could choose a sporty, six-pot 323i sedan with extras for the price of a four-pot Mercedes.

BMW promoted these cars as 'The Ultimate Driving Machine'. Yet, if BMW's sporty German image wasn't enough, 1978 saw the launch of the company's Motorsport division. Their products may have been branded 'M', but to all intents and purposes these were Q cars. The M5, for instance, launched in 1984, looked deceptively like a regular 5 Series, yet its performance was faster than a Porsche 911 of the day.

In 1995, BMW launched its Z sports range and in 1995 its X range – SUVs, something of an image challenge for a company that had concentrated on sporty sedans and sports cars throughout its history.

The growing threat of climate change would provide yet another image challenge for a company wedded to designing and refining the internal combustion engine. In 2010 BMW's first hybrid was created, followed by its xDrive plug-in hybrids. In 2013 the i3, BMW's first all-electric automobile, came on the market.

Over the next three years, BMW will be spending one billion euros on preparing its e-drive system at its Steyr plant in Austria. Time is of the essence, because by 2035 the sale of new internal-combustion-engine cars will be banned throughout the EU and in other parts of the world too.

High performing, sophisticated, reliable, user-friendly, low depreciation, good value – you would be hard-pressed to name a mass manufacturer of cars offering all this before BMW. But now the company must hold fast to its philosophy as it enters an all-electric future. A tough call, but BMW will deliver.

And here are 50 reasons why we love them...

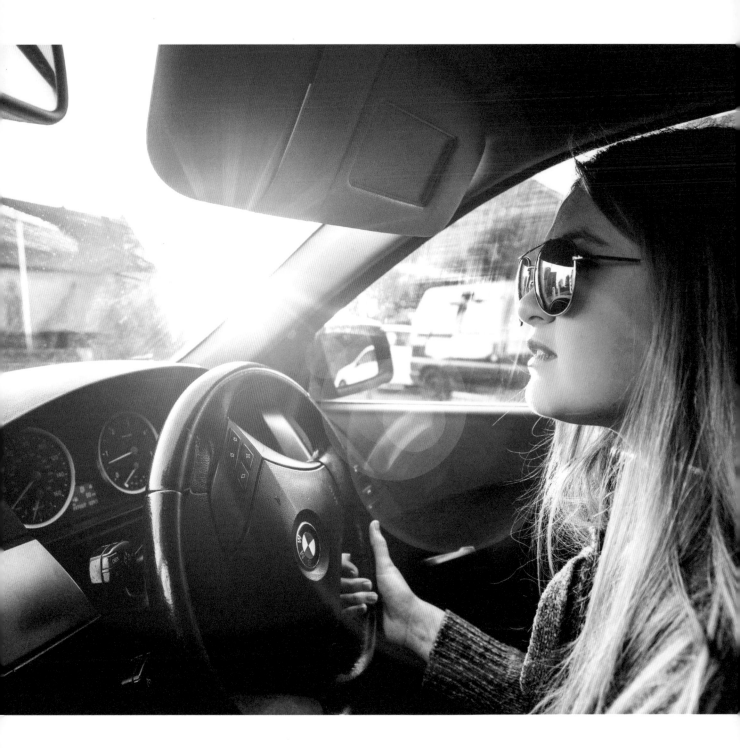

01

THE BMW IMAGE

We are in Stoke-on-Trent, England, the world-famous pottery town. A young woman at the wheel of a BMW 5 Series is checking her rear-view mirror.

And here is the First Day's Vase, one of four surviving, designed and made on 13 June 1769 by the potter and entrepreneur Josiah Wedgwood to mark the first day of his new factory in Stoke-on-Trent.

Wedgwood's company designed elegant, high-performance ceramics. They became instant classics. That wasn't all. Wedgwood innovated with marketing methods: promotion, production and world-wide export. His company's research and development was ground-breaking. It all meant that rival potteries would be forever playing catch-up.

The Wedgwood image. Elegant, high performance, understated, classic. And now BMW. Seen here in a Stoke-on-Trent car park.

Left: At the wheel of a BMW 5 Series. Right: The Wedgwood First Day's Vase on display at the Potteries Museum and Art Gallery, Hanley, Stoke-on-Trent, UK.

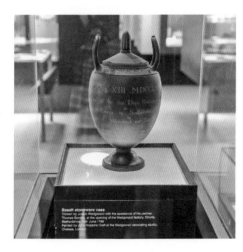

02

MODEST BEGINNINGS

In the mid-1920s Automobilwerk Eisenach in Germany was struggling to sell its cars, unsurprising as the country was in a deep depression because of the war reparations imposed by the Treaty of Versailles after the First World War.

The company decided the only way forward was to make a very small car. But without the money to build one, they had no choice but to take out a licensing agreement with a company that did.

The car they chose in 1927 was the Austin 7, an economy car designed by Sir Herbert Austin himself in the billiard room of his country house outside Birmingham. It was simple yet well thought out, a car for those with just enough money to become motorists for the first time.

Automobilwerk Eisenach paid a royalty to Austin on each car they built. They called it the BMW 3/15, also known as the Dixi. Few alterations were made, as can be seen, other than changing the nuts and bolts to metric, and building the car left-hand drive. But the going was tough for the under-capitalized Automobilwerk Eisenach. In 1928 they were bought out by BMW.

So was born the first BMW automobile. It laid the path for the company's belief in designing cars that did exactly what they said they would do.

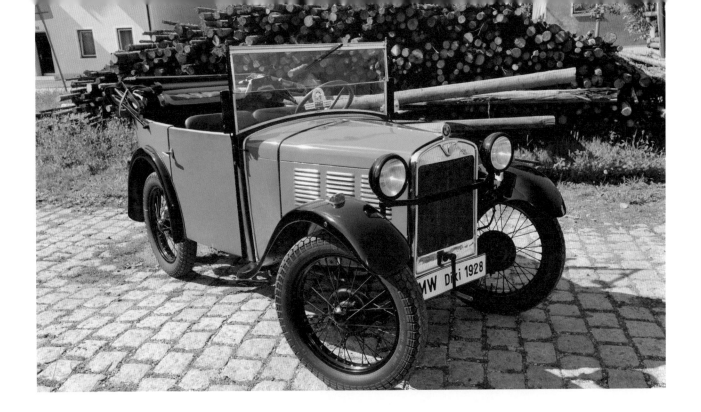

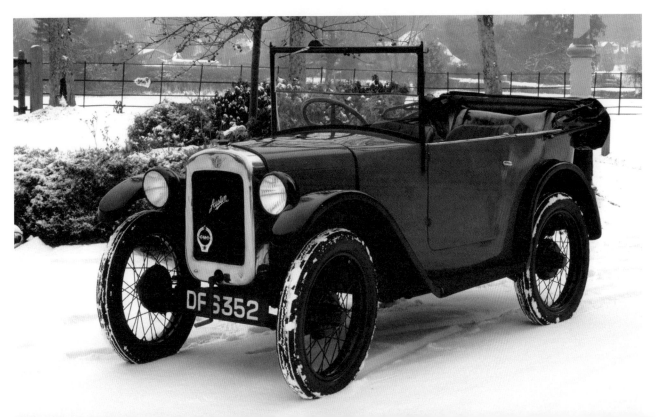

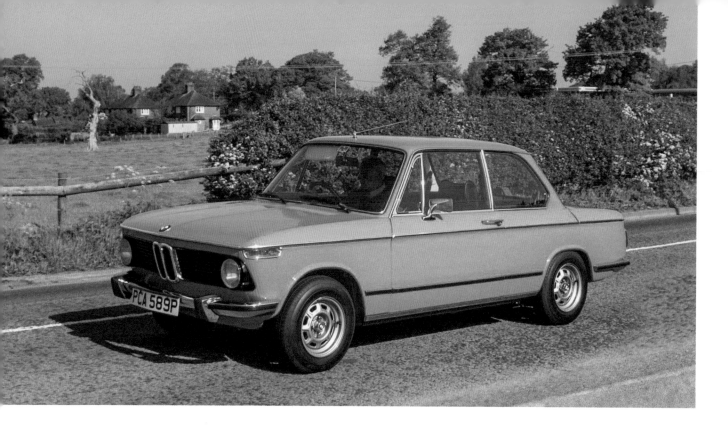

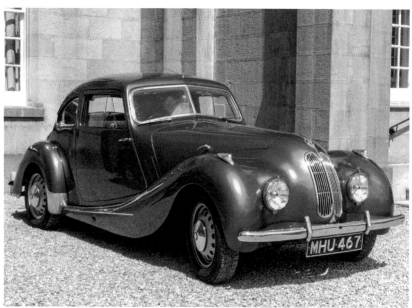

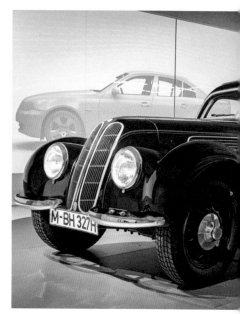

03

A BRILLIANT CAR DESIGNER

Fritz Fiedler was the design engineer most responsible for the classic pre-war BMWs, the BMW straight-six engine (developed further for Bristol Cars), the Bristol 400 and the post-war BMW 'New Class' of sports saloons. Here is a 1938 BMW 327 (opposite, below right), designed by Fiedler and built at their Eisenach factory.

In England, the Bristol Aeroplane Company looked to diversify after the Second World War, as military orders tailed off. BMW cars had been imported to Britain by a company called AFN before the war. They had also been advising the Bristol Aeroplane Company on setting up a car division.

In 1945, H J Aldington, a director of AFN, travelled to Munich where he purchased, from bomb-devastated BMW, a licence to manufacture a car based on an existing model. He persuaded Fritz Fiedler, BMW's chief car designer, to come to England to work on the new AFN/Bristol project.

The result was this 1949 Bristol 400 (opposite, below left). It has a chassis from a 326, an engine from a 328 and bodywork from a 327, the latter in aluminium as Bristol, being an airplane company, had surplus available. This made it a lightweight, powerful automobile with a low centre of gravity. When it was launched in Britain, it caused something of a sensation.

Three years later, Fritz Fiedler returned to Germany and BMW, where he would set the standard for BMW's post-war success. His 1500 to 2002 small sports sedans became the pattern for both the engineering and the purposeful, unadorned look of today's BMWs.

Here is a 1976 2002ii (opposite, above), the last model made before the introduction of the 3 Series.

17

04

REINVENTING BEAUTY

This 507 from 1956 is one of the most beautiful-looking BMWs ever made. It was designed by Fritz Fiedler and Albrecht von Goertz. Yet it was so expensive, fewer than three hundred were sold in three years worldwide.

Seen in the BMW Museum in Munich, Germany, this car was owned by Elvis Presley, who purchased it in Germany when he was stationed in the US Army. Fans scrawled their private thoughts all over it in lipstick, so Elvis had the car painted red.

Now it is back in its original colour ... though just a few lipstick additions may have added some historical panache.

Because they are rare, a 507 is very valuable indeed. In July 2018, a 507 owned by John Surtees, the only man to be a world champion in motorcycling and Formula One, sold for $5 million.

Forty years after its launch, the 507 influenced the styling of BMW's Z range, most of all its Z8. This 1999 car (opposite, below), with bodywork designed by Henrik Fisker, incorporates many of the 507's elegant cues.

In 1999, James Bond's Z8 was cut in half by saws carried by a helicopter in *The World is Not Enough*. But even a Bond movie didn't help sell enough Z8s, so reluctantly BMW ended production of this hand-finished car too, as they had with the car that inspired it.

Today a Z8 is one of the best investment buys of any car of the modern era.

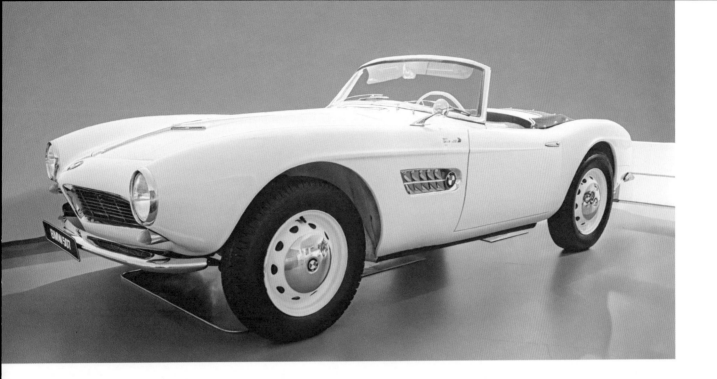

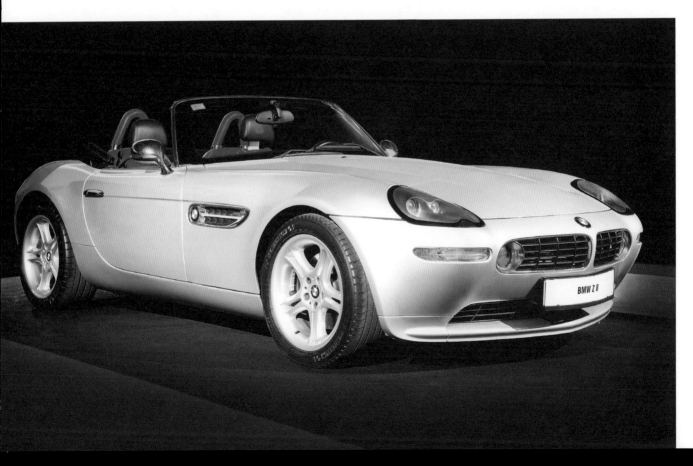

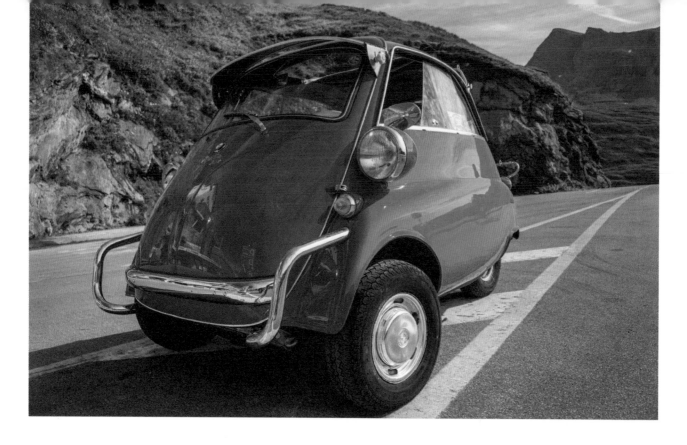

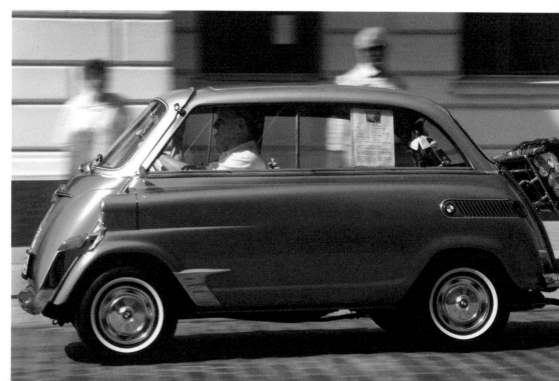

05

CUTE BMW

The two-seater BMW Isetta bubble car was made from 1955–1962. It was first available in 1953 from the Iso company in Italy (Isetta meaning 'little Iso') with a two-stroke 236cc motorcycle engine.

When BMW bought a licence to produce the Isetta, they fitted their own engine. This was unsurprising, as the BMW name was synonymous with quality motorcycles. The BMW engine meant that their 250 model was faster than the original Italian version and could now reach a staggering 53mph (83 km/h).

In 1956 BMW introduced a revised engine with 300cc, the 300. Although the top speed remained the same, the car had much more pulling power. This red one has managed to top Austria's Grossglockner High Alpine Road.

In 1957 BMW introduced a four-seater version, the 600, equipped with the 582cc engine used in their R67 motorcycle. Yet by this time, anyone looking for a small, reliable, four-seater European car preferred the more conventional VW Beetle or Bug, so few 600s, such as this green beauty, were sold.

But BMW's 600 sales flop did provide a couple of legacies. Its chassis became the basis for the company's first post-war small car, the BMW 700. And the 600's independent semi-trailing arm rear suspension would be used in every regular BMW until the 1990s, helping develop the company's reputation for designing cars with sporty handling and road-holding capabilities.

Mistakes are sometimes made at BMW, but when they are, they are learned from.

By the way, have you ever seen a cuter Bimmer with its trailer than this?

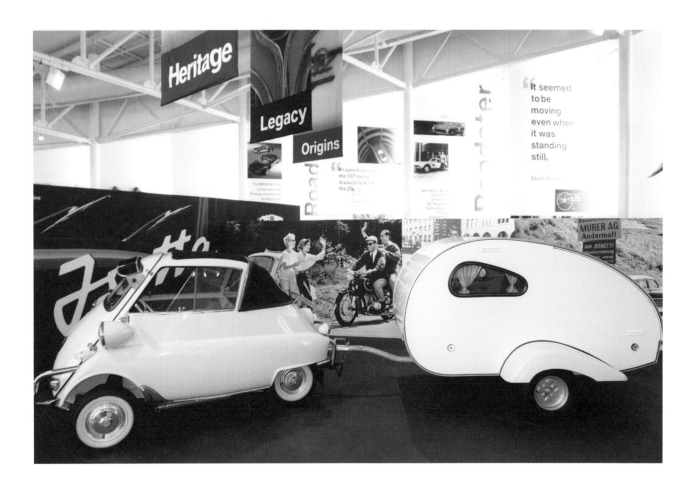

Das ist Ihr Wagen:
Geräumiger Innenraum mit vier bequemen Sitzen · viel Platz für Gepäck · lebendiger, laufruhiger Viertaktmotor - 30 PS · vollsynchronisiertes Vierganggetriebe . . . und eine elegante, begeisternde Form - **natürlich ein BMW 700**

BMW ⊕ 700

Opposite: BMW Isetta
bubble car with trailer.
Above: 1960s advert for
the BMW 700.

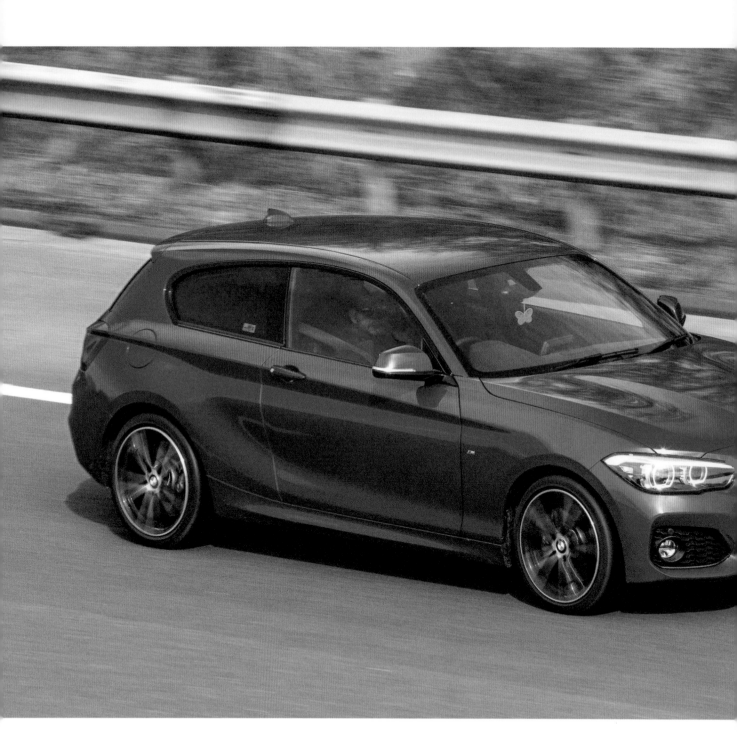

The 118D M Sport
Shadow Edition.

06

THE 1 SERIES

The 1 Series was introduced in 2004 as BMW's first sub-compact. It is now on its third generation.

The first two were, as you'd expect, classic BMW rear-wheel drives. That made BMW an outlier in the hatchback market; unsurprising because, whatever the size of car, BMW had always kept well clear of the front-wheel-drive business.

In 2012, a 1 Series four-wheel-drive version, the xDrive in BMW-speak, was introduced. That in itself was not terribly revolutionary as there were plenty of other four-wheel-drive hatchbacks around by then.

But in 2019 the present generation of the 1 Series, seen here, introduced front-wheel drive. The dyed-in-the-wool BMW purist may have been sniffy, but with a range of petrol and diesel engines to choose from, a 1 Series front-wheel drive does drive pretty well.

07

THE 2 SERIES

In 2014, BMW launched its 2 Series, based on the coupés and convertibles of the updated 1 Series. Perhaps because they were sporty and more exclusive, BMW decided that they would now be badged the 2 Series.

The following year, a compact MPV called the Active Tourer was introduced. There are two unusual things about this. Firstly, the MPV was badged a 2 Series – an odd bedfellow for a stylish coupé and convertible. Secondly, it was the first BMW to use front-wheel drive. Shock horror for some.

For most of us, coupé means a two-door car. That was until 2019, when a four-door version of the BMW 2 Series coupé was launched, called the Gran Coupé.

If you are baffled by the branding, here is a cabriolet at the 2019 Geneva Motor Show.

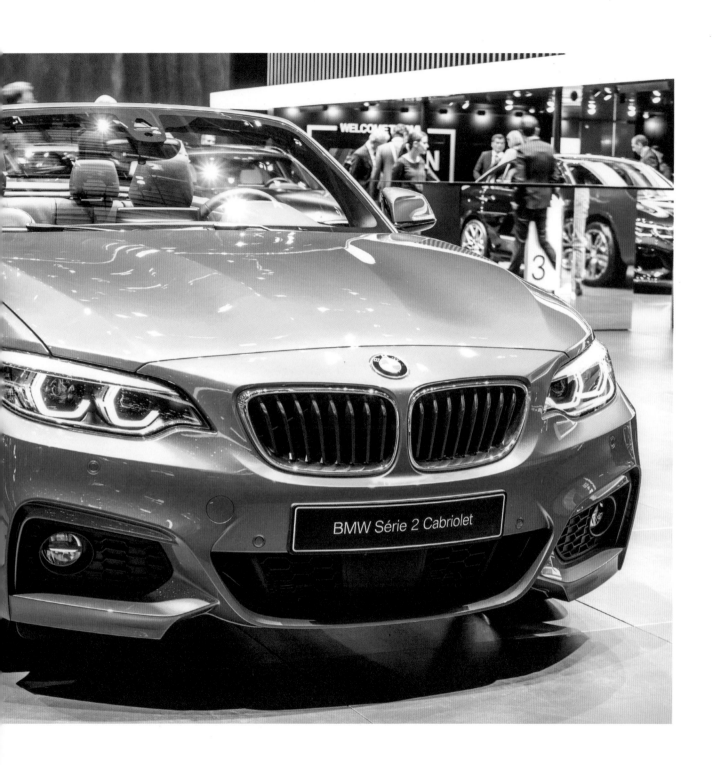

BMW Série 2 Cabriolet

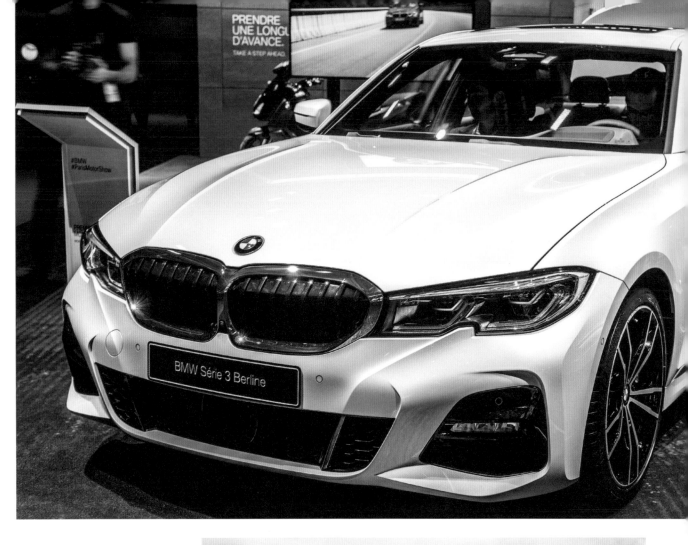

Above: The 3 Series 320 Berline. Right: The 3 Series Baur Cabriolet E21.

08

THE 3 SERIES

In 1975 the launch of the BMW 3 Series caused a stir.

Before the 3 Series, European performance cars could be on the demanding side to drive and not always reliable – Alfa, Lancia, Triumph, Jaguar. Even BMW's previous model, the wonderful 2002, could be a little tricky in the wet, as this writer remembers only too well.

VW's Golf GTI, launched the previous year, was something of a rival except it was a go-faster, re-engineered version of the basic Golf. The 3 Series was not that. It was a sophisticated performance car whichever version you chose.

The mainstream manufacturers were rattled. A company's salesperson could now ask for a six-cylinder BMW 320i instead of a top-of-the-range British Ford Cortina on the grounds that the company's outlay would be not much more and the depreciation far less. BMW's four-cylinder 3 Series cars were also better bets than Chevrolets, Opels, Renaults and other US and European 'middle manager' cars.

BMW is now on the seventh generation of its best seller. A 3 Series remains instantly recognizable, whether it is a first-generation E21, such as this Baur Cabriolet, or a latest generation G20. Both are sleek, understated and with just enough hint of menace.

09

THE 4 SERIES

In 2013, BMW did what it would do the following year when it created the 2 Series out of the 1 Series – it spun off its coupé and convertible models into a 'new' series: the 4. Unlike the 1 and 2 Series, the classic BMW rear-wheel drive was retained. X-drive was also available, as were BMW's classic in-line engines: turbocharged three, four and six-cylinder, petrol or diesel.

By the way, we mustn't forget that automotive misnomer, the four-door 4 Series Gran Coupé (actually five-door, as it is a lift-back), but we've already been there.

More interestingly, the second generation, as seen here, included a plug-in hybrid, so it is unsurprising that now, being on the way to electric, the BMW 4 Series looks remarkably like the all-electric BMW i4.

The BMW 420i.

10

THE 5 SERIES

If there is one BMW model that upstages the classic 3, it has to be the 5, because it introduced the new numbered series, the series that would put BMW on the big-boys map. Launched in 1972, the 5 Series made BMW more money per model than any other. Indeed, it is still the number-two best-selling BMW after the company's 3 Series.

The 5 was aimed at the company director – an executive luxury-car market with tough competition from Mercedes with their W114/115 models, and Audi with their 100/200 (5000 in the US) cars. That is without mentioning the smaller manufacturers such as Jaguar and Volvo. In the US, the 5 Series would be equally worrisome for General Motors with their Cadillacs and Ford with their Lincolns.

Their problem didn't go away. The motoring press raved about the 5 Series from the beginning. Indeed in 1996, with the introduction of the new E39, the 5 Series was being lauded in the motoring press as the best car in the world.

Why has the 5 Series been such a hit for BMW? Well, apart from the obvious fact that it is an excellent car – fast and reliable – I think it happened to hit the zeitgeist. The company executive it was aimed at was changing.

Starting with the baby-boomers, the new power-play types did not want to appear stuffy and distant. They were younger, and not just in years. They wanted luxury without it blatantly saying so, and with the 5 Series they got it.

Eventually, so did the competition. For many years now Audi, Mercedes et al have had their unobtrusive and luxurious offerings too. But the BMW 5 Series got to the zeitgeist first. Especially when Jackie Onassis bought one.

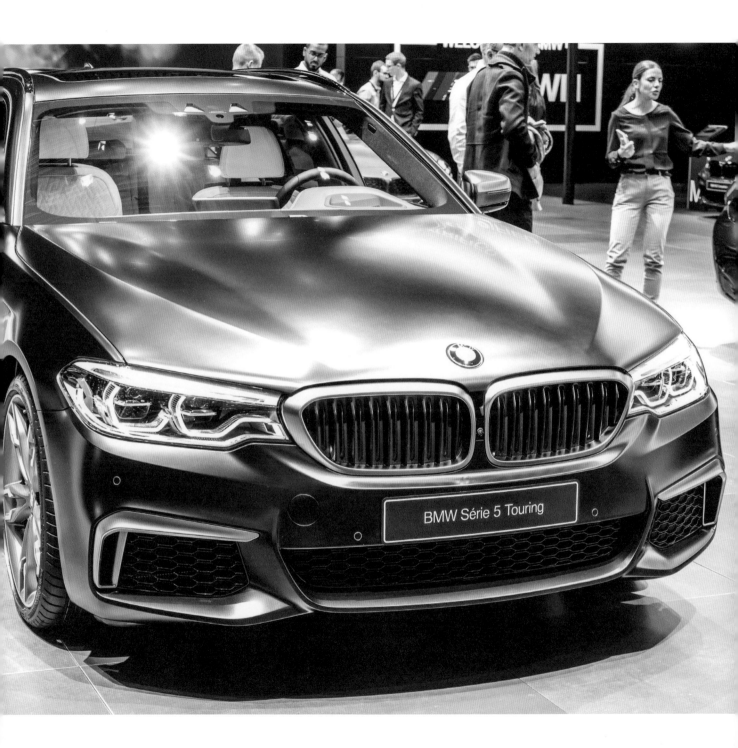

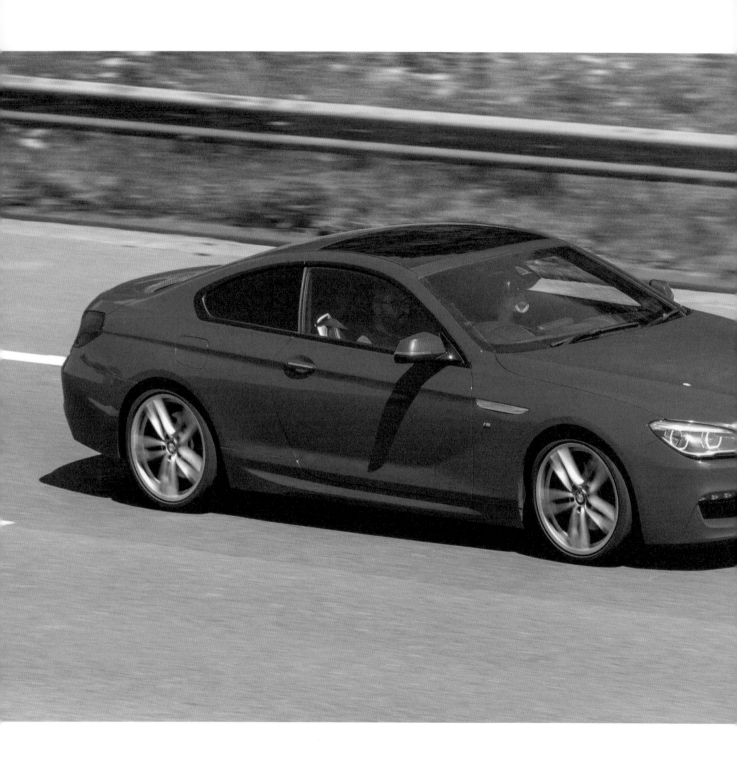

11

THE 6 SERIES

The 6 Series started life in 1976 as the E24. In many ways it represented BMW's key assets – a powerful straight-six engine, rear-wheel drive and an elegant coupé body. The 635 CSi would become the quintessential German grand tourer.

The second generation, the E63, introduced in 2003, which included a cabriolet model, was based on a shortened 5 Series chassis. Like the new 5 Series at the time, it attracted criticism for what was regarded as an over-stylized body. Many considered it too in-your-face for a car company that had always celebrated Bauhaus understatement.

Even more controversial, especially in the US, was BMW's new iDrive system, particularly from a company that had pioneered high-performance cars that were easy to drive. Pictured is the F13, a two-door coupé version of the F12, produced from 2011–2018.

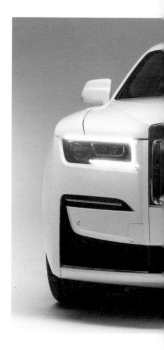

12

THE 7 SERIES

The plutocrat end of the market is where the new 7 Series headed when it was launched in 1977. This was going to be tough territory for BMW's new flagship model.

Could the company really dislodge or even offer a credible alternative to a top-of-the-range Mercedes-Benz, made by a company that had bestrode this market segment for as long as anyone could remember?

Yet there have been seven generations of these BMWs, in stretch and limousine versions as well as sedan, boasting technical innovations that have led the field. In 2022 an all-electric version was launched.

When you look at the evolution of each of BMW's numbered series cars, what is striking is how conservative the changes to the 7 Series have been in comparison. BMW had clearly decided to be more restrained when it came to challenging the Mercedes S-Class, the Audi 8 Series and later prestige Japanese products such as the Lexus LS.

If you do crave more attention and can afford it, you could buy a Rolls-Royce instead, because it looks remarkably like this X7 concept car. But for anonymous luxury and doing your bit for the planet, you'd be better off with the new electric 7 Series xDrive60. Those bits of BMW blue are so subtle that you will never be accused of virtue-signalling.

Above: The 2021 Rolls Royce Ghost. Above right: The BMW X7 Concept. Right: The BMW xDrive60.

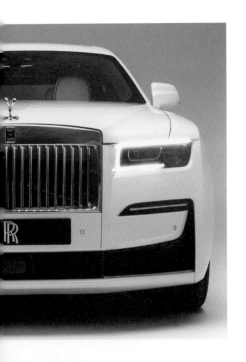
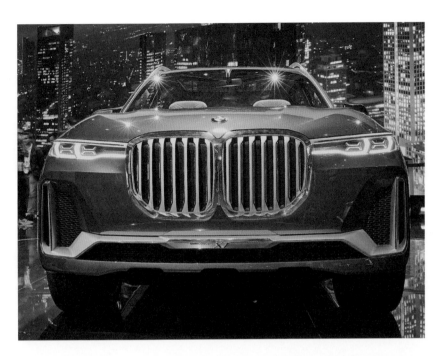

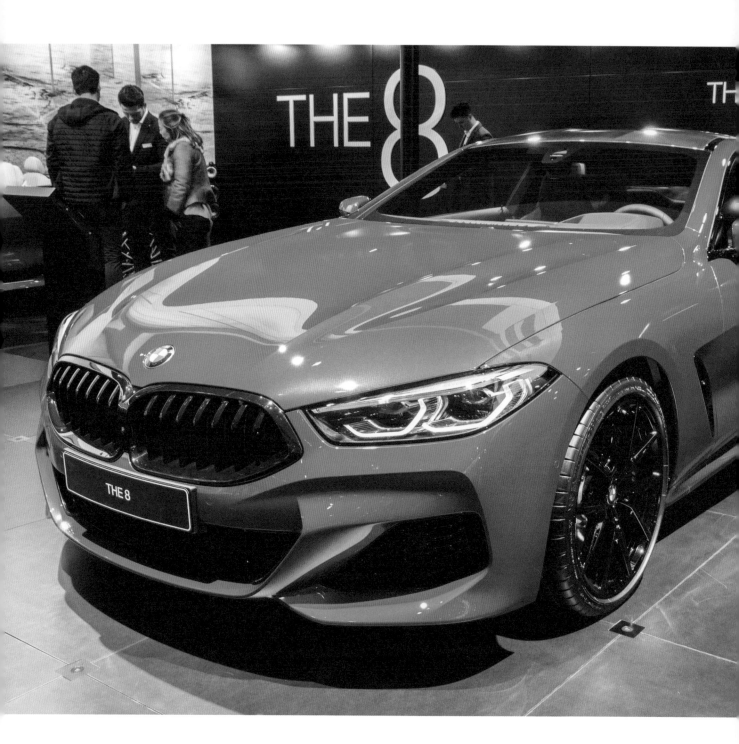

13

THE 8 SERIES

The 8 Series was first introduced in 1990 but was withdrawn in 1999 as sales were disappointing. It is amazing it took so long to kill, because ever since BMW nearly went bust in 1959, the company has been ruthless with any model that didn't sell, such as the Z8.

But in 2018, BMW decided to have another go. Its much bigger German competitor, Daimler, had its Mercedes AMG GT coupé and four-door coupé, while VW had its Porsche 911 and Panamera.

Based on a 7 Series platform, and even flashier than the 6 Series, these cabriolets and coupés – including a Gran Coupé – are about as blingy as BMW is prepared to go. For the moment.

The 2020 BMW
8 Series.

14

THE X SERIES

Daimler and VW don't just make cars. They make trucks and buses too. But BMW has always focused proudly on sporty cars and motorcycles. Sheer Driving Pleasure.

So when BMW moved into the burgeoning SUV market in 1999 with its new X5, eyebrows were raised. Who else with a proud sporting pedigree would do so? Saab had, reluctantly, with its 9-7X in 2005 for the US market, but it was under orders from its owners, General Motors. Saab then went bust. Lancia did in 2011 with its MPV, which was mercifully killed in 2015. Alfa Romeo has had its Stelvio SUV crossover since 2016.

BMW doesn't like the SUV badge – Sport Utility Vehicles – as indicating too much off-roading. The BMW driver wants sheer driving pleasure and that mainly means road-handling. So in BMW-speak the cars in their X range are called SAV: Sports Activity Vehicles.

Today the Xs – made in Spartanburg, South Carolina, because North America is the main market – compete in a very crowded market: Porsche, Lexus, Mercedes, Audi, Bentley, Lamborghini, etc., are all there.

It could be charged that BMW acquired a ladder and kicked it away once they had climbed it. That ladder was Land Rover, a company that, through its Range Rover brand, had actually invented the SUV. BMW bought Land Rover in 1994 but sold it in 2000. They learned from the

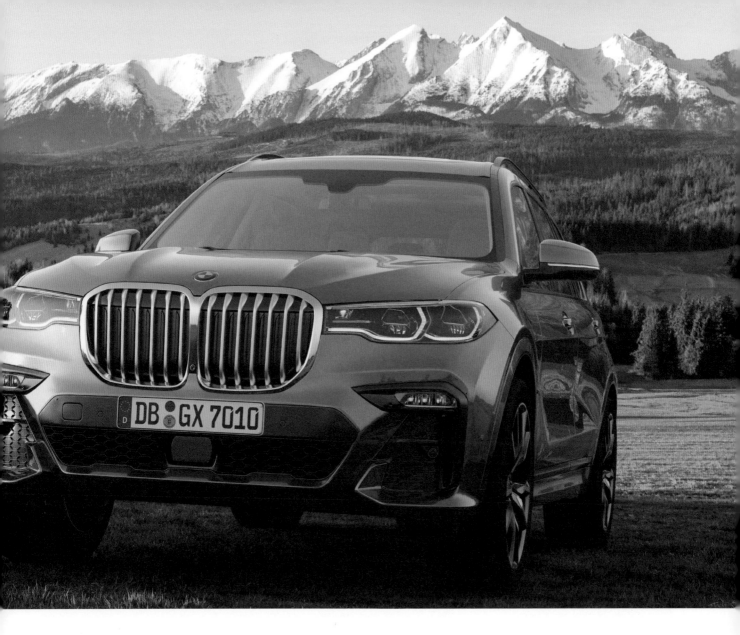

off-road and on-road capabilities that had made the Range Rover name. But in the end, BMW wanted an SAV that was more on-road than off and with less of the Range Rover's reputation for being fixed up in the shop far too frequently. The X5 and its derivatives was it.

Here is a luxurious X7 in the Bavarian Alps, parked on a sensible piece of ground. Unsurprisingly, it's a beautiful and reliable car to drive.

The BMW X7.

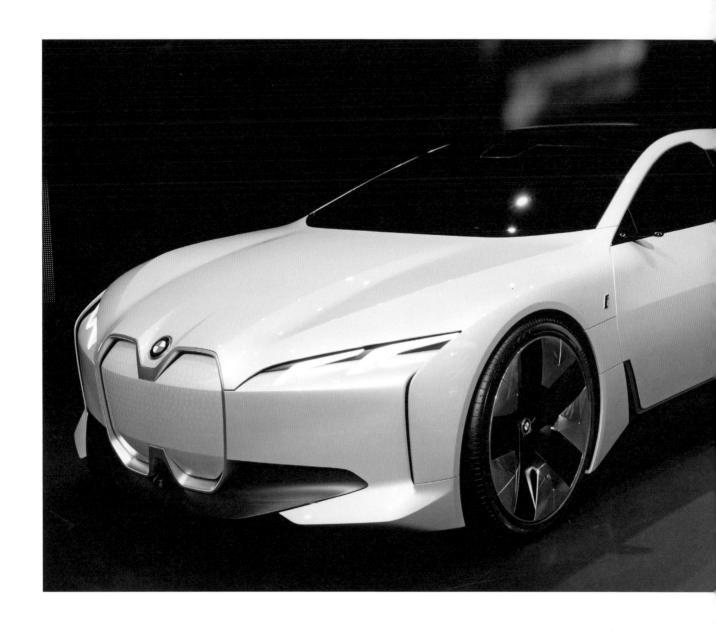

The i Vision Dynamics
electric concept car.

15

THE I

I love this picture of a BMW i Vision electric concept car at the Frankfurt Motor Show in 2017. Surely Captain Kirk of *Star Trek* should be stepping out of it.

The i brand was founded in 2011 to design and make plug-in cars, but in 2013 a leap-frogging took place when BMW's first all-electric car, the i3, went on sale. For its core-brand models, such as the 3 Series, the idea was to provide plug-in hybrid versions. This was a well-thought-through holding operation until battery technology and an extensive charging infrastructure had developed to justify the inevitable switch to all-electric in all BMW models.

But BMW could not itself drive international advances in battery technology or the roll-out of a charging infrastructure. So BMW has not been a pioneer in the electric revolution. It now has its all-electric i3, with an optional range-extender, which is the number-three best-selling all-electric vehicle in the world after the Tesla Model 3 and the Nissan Leaf, plus its plug-in i8 and its iX cars. By 2025, BMW aims at 15–25 per cent of its sales to be electrified.

BMW is up against that new kid on the block, Tesla, not to mention the vast resources of its two German competitors, as well as the Japanese and Korean giants. A director of BMW summed up the problem to me as we stood outside their museum in Munich ten years ago. Pointing at a Toyota Prius parked across the road, he said, 'The challenge is, Vaughan, that the company who developed and made that over there has a larger R&D budget than our turnover.'

But BMW will get there. Because BMW buyers want an exciting car, and not a BMW Prius.

16

THE M

BMW's Motorsport division was established back in 1972 to develop and support the company's racing cars. Road-going cars were then tuned by the Motorsport division, examples being the elegant 3.0 CSL and the 530MLE. In 1978 the Motorsport division made a car available for commercial sale – the M1. But it was really a racing car.

The following year, a regular BMW M – or what appeared to be, and this is important – could be bought commercially. It was a 535i, to which the prefix M had been added.

BMW realized that there was a market for a Q car, looking for all intents and purposes like any other BMW, but that was in reality an iron fist in a velvet glove. Only a few design cues would give the game away: a discreet M badge, although some buyers had it deleted, lower suspension, four tail pipes, etc.

But, to most people, the car looked unexceptional. And that was the point.

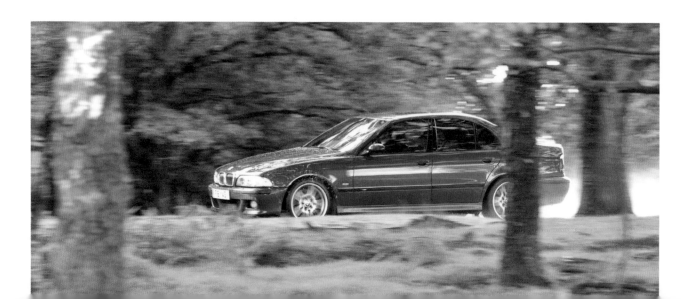

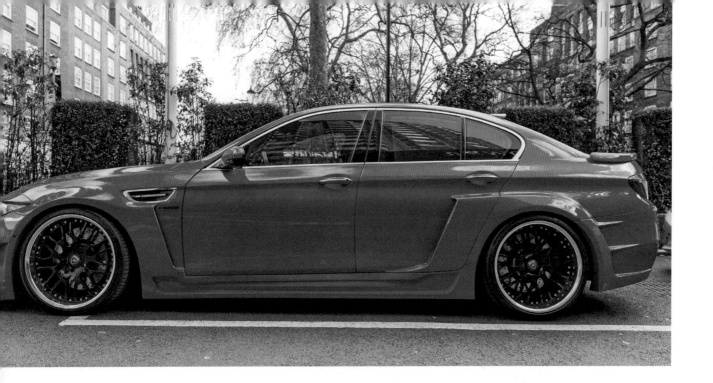

At first the M division chose only models that would benefit from their makeover. That meant the E28 M5 and the E24 M635 CSi. A big, naturally aspirated, high-revving engine rather than a supercharger or turbocharger was chosen because it complemented the suppleness and road-holding ability of these models more effectively. But new international regulations on fuel consumption and CO_2 emissions in the late 2000s meant that turbochargers on smaller engines would now have to be used.

Today, more or less any BMW can be bought with an 'M Sport' badge, which means sports seats, sports steering wheel, etc. Only a bigger 'M' means the real thing. There is also something in between called 'M Performance'.

So let's return to the original idea. Here is a blisteringly fast M5 in 2000 speeding through woods (opposite), looking for all the world like a regular 5 Series. And here is an M5 in 2016 (above), in Knightsbridge, London. With bodywork by Hamann, this is one of those cars brought to the city every summer by Middle East billionaires, just for rumbling around the block in. Which M5 better expresses the true spirit of BMW?

Opposite: BMW M5 E39.
Above: A customized 2016 BMW M5.

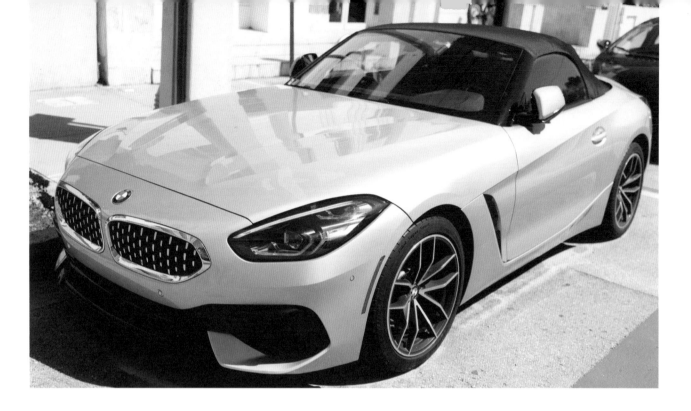

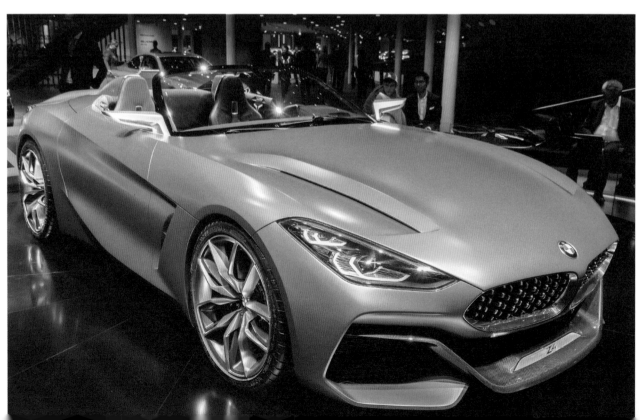

17

THE Z

Z stands for *Zukunft* or 'future', which helps explain why these sports
models look futuristic.

The first, the Z1, was launched in 1989. It lasted until 1991, followed by
a lull until 1995, when the Z3 was launched. Was there no Z2 because it
could be mistaken for Zz?

The Z3 Coupé was disparagingly called the 'clown shoe' on account
of its challenging looks, although it did make it into the Bond movie
GoldenEye.

In 2003 the Z4 was announced, and this longer and better-
proportioned model, by Danish designer Anders Warming, looked more
the business. The second-generation Z4, designed by Juliane Blasi and
Nadya Arnaout, was launched in 2009. The third-generation Z4 sports
car is shown here in 2017 at the Frankfurt Motor Show (opposite, below).

It is interesting to note the subtle design changes between Frankfurt and
2021 when this brand-new silver Z4 was photographed in Los Angeles
(opposite, above). It shares its platform with the Toyota Supra J29.

And then there was the stunning Z8 with a ticket price of $128,000. It
didn't sell well so was withdrawn. Today a collector's Z8 will command
quite a bit more than that.

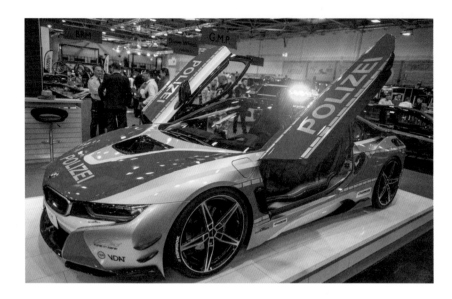

18

THE CUSTOM

You would not have thought it necessary to customize a BMW. After all, AC Schnitzer, G-Power and Hamann did it perfectly. But it cost.

Here in Thailand (opposite) is a Z4 E85 Roadster, boasting a deliberately distressed look. What would Anders Warming, its original designer, have thought? Actually, Infinite Motorsport have done a pretty original job. But the crude spoiler?

You can, of course, buy custom off-the-shelf such as the M5 by Hamann we saw in London's Knightsbridge on page 45. Or you could have one customized to your own specification.

The i8 police car (above) is a case in point. Here in Essen, Germany, in late 2018, is the campaign vehicle for the 'Initiative for Safe Tuning'. The German police were concerned enough about the growth in amateur customization of fast BMWs to launch their campaign. The tuning here has been undertaken by AC Schnitzer.

Above: A BMW i8 police car. Opposite, above and below: Customized BMW Z4 E85 Roadster.

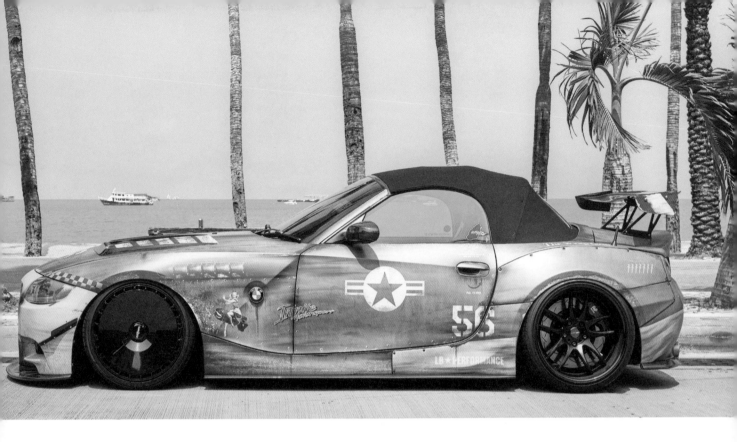

49

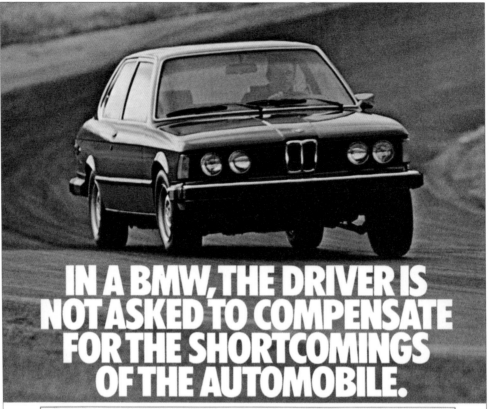

IN A BMW, THE DRIVER IS NOT ASKED TO COMPENSATE FOR THE SHORTCOMINGS OF THE AUTOMOBILE.

The extraordinary road-holding ability of the BMW 320i is graphically illustrated, above, travelling at a high speed through turn # 6 at the Sears Point International race course. Note: as the BMW goes into the turn, the unique angling of the MacPherson front struts reduces the lean of the inside front wheel, while the outside front wheel remains vertical; inside and outside rear wheels remain vertical due to semi-trailing arm design in the rear.

Like all honeymoons, the first few months of new car ownership are generally a period of adjustment.

A time when man accommodates himself to the idiosyncracies of his machine—those little quirks of engineering that make the act of driving something to be endured rather than something to be enjoyed.

Perhaps because of our long involvement in motor racing—where such an antagonistic relationship would be intolerable—we at the Bavarian Motor Works in Munich, Germany, take a wholly different approach to building automobiles.

An approach that begins with the seemingly unusual engineering concept that, above all, a car must function as one with its driver.

© 1978 BMW of North America, Inc.

YOU DRIVE A BMW.
IT DOES NOT DRIVE YOU.
When you drive the BMW 320i for the first time, you will experience a curious sensation of being part of the car itself—an exhilarating feeling of control.

When you press the accelerator, the two-liter, K-Jetronic, fuel-injected engine responds without lag.

Its four-speed transmission (automatic is available) slips precisely into each gear.

The suspension—independent on all four wheels—is quick and clean through the corners.

Its rack and pinion steering is sharp and accurate.

Careful study has been made of the critical relationship between seat location, visual position, steering wheel angle, pedals and controls.

Instruments are clearly visible and illuminated at night by an optically beneficial orange light; controls are readily accessible.

Pedal direction and pedal pressure have been carefully balanced to reduce fatigue and facilitate effortless gear changing.

All told, the only major adjustment you will have to make as the new owner of a BMW 320i is that you will have no adjustments to make at all.

If the thought of owning such a car intrigues you, call us anytime, toll-free, at 800-243-6000 (Conn. 1-800-882-6500) and we'll arrange a thorough test drive for you at your convenience.

THE ULTIMATE DRIVING MACHINE.
Bavarian Motor Works, Munich, Germany.

19

THE ULTIMATE DRIVING MACHINE

BMW's advertising has always concentrated on drivability. Whatever it looks like, whatever it sounds like, however comfortable it is, the main thing is to make us want to get behind the wheel of a BMW. With the Ultimate Driving Machine, BMW pioneered a sedan that went like a sports car and was also easy to drive.

This is spelled out in the US ad for the 3 Series back in 1978. No idiosyncrasies to get used to. 'You drive a BMW. It does not drive you.'

Some punters saw a sports car as a racehorse – easy to control once you got the measure of it. Off they went to buy an Alfa Romeo or a Saab Turbo. BMW said, 'Not us.' Which is why they sold so well.

It was more of a challenge to advertise a BMW in North America than in Europe. Advertising an automobile on its speed capabilities has been a no-no for a long time, thanks to lower speed limits in the US, and fierce American litigation. Should there be an automobile accident caused by speed, the car manufacturer risked being sued for millions.

Not so in the UK. An advertisement for the 3.0 CSi in the early 1970s blatantly encouraged less caution thanks to the car's acceleration and 132mph (212 km/h) top speed.

Today, BMW advertising is more sophisticated. They know that a cool picture of a BMW, or even part of one, will be a lot more intriguing than a thousand words.

1978 US BMW advertising.

20

GO COMPARE

The DTM (Deutsche Tourenwagen Masters) is a grand touring car series that has been around since 1984. But BMW stayed away for 20 years. In 2012 they returned to the fray, winning the titles for drivers, teams and manufacturers.

BMW had wanted an international series, rather than one focused on Germany. I think we can guess which country they would rather be in, given the importance of their sales there, although today their big market is China.

Here is a BMW M3 flanked by an Audi A5 and a Mercedes C Coupé at the Hockenheimring – appropriately enough seeing as, since the Second World War, BMW has been competitively flanked, and not just on the racing circuit, by the Daimler-Benz and VW conglomerates.

BMW is a loner – a medium-sized company focused on innovating and refining sporty automobiles and motorcycles. And, in terms of bangs per buck, the most profitable. Which, of course, is a great place to be.

But BMW also has to decide where, when and how to compete. This isn't always easy, especially when you know it will not be long before your innovations are copied yet again.

Audi, BMW and Mercedes DTM cars lining up at Hockenheim, 2011.

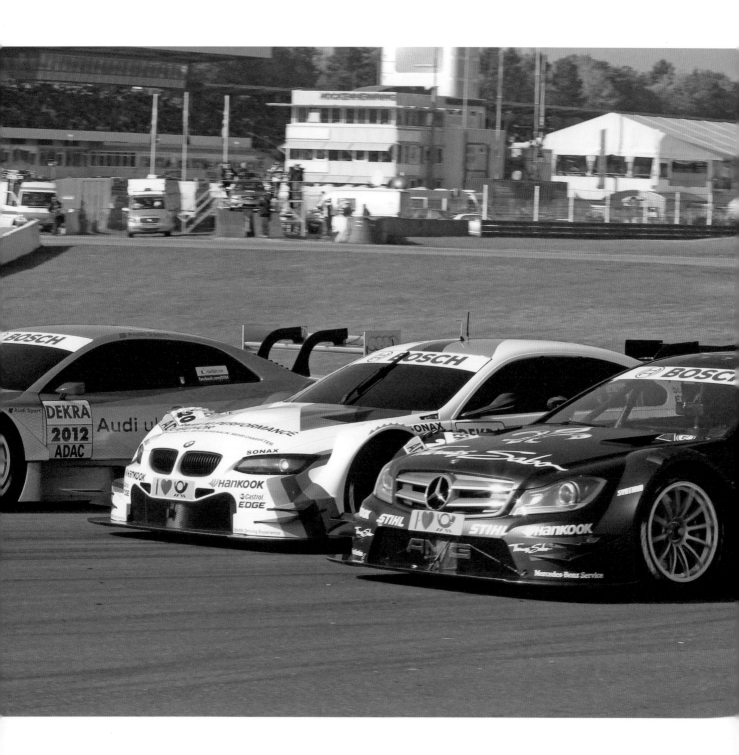

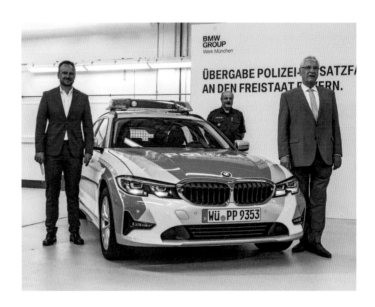

21

POLIZEI BMW

You are driving on the autobahn and you glance in your rear-view mirror. Where did that come from? It's closing in fast. That double-kidney radiator. And then, at warp speed, it shoots by, siren wailing. Wow. So that wasn't about me.

Police departments all over the world love BMWs because they are reliable. And very quick, especially with that 155mph (249 km/h) speed limiter removed.

Here is the interior minister of Bavaria viewing the new G20 3 Series. I don't have to point him out. Presumably the rest would like to know how big that order will be.

Buying Bimmer has a long police history. This BMW Isetta is from the 1950s. Whatever was it used for? Would it be fast enough today to catch a city cycle warrior running a red light? That would keep it busy.

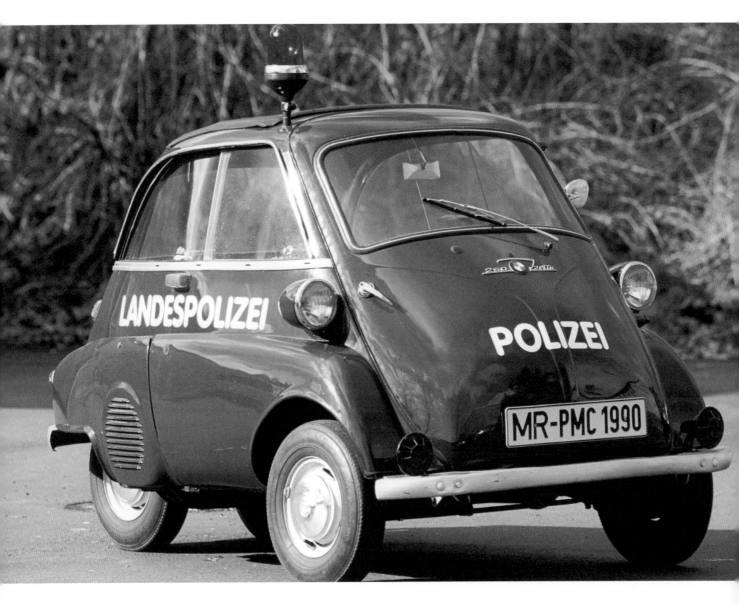

Opposite: Joachim
Herrmann, the Interior
Minister of Bavaria,
viewing the G20 3
Series police car in
Munich, 2020. Above:
1950s Isetta police car.

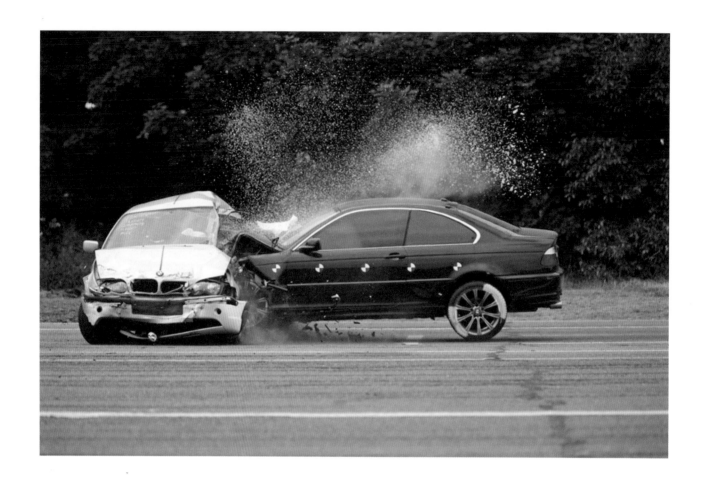

Organized crash by
the Institute of Traffic
Accident Investigators.
To the left, a 3 Series
E46, to the right, a 5
Series E39.

22

BODY BUILDING

I once owned an E39 530d Touring.

The car was only six months old and I was driving with my children up the A1, which runs from London to Scotland. We had made a short break for soft drinks and had just rejoined the road. I was doing about 50 in the inside lane of a dual carriageway when it happened.

A truck directly ahead began to veer from side to side, its long, empty trailer weaving alarmingly. The tractor end of the truck headed into the near-side ditch. Its trailer was beginning to jack-knife and it was about to shut off both lanes to us.

In my rear-view mirror, a huge cement truck was bearing down on us. We were about to get sandwiched.

Dropping the 530d into third, I floored the loud pedal and headed for the fast-closing gap between the back end of the jack-knifing trailer and the central reservation. The 530d shot forward thanks to its superb mid-range acceleration.

We only just made it. But the trailer slowly swung and hit us the other side, sliding our car down the road. But we avoided the huge impact that now took place between the trailer and the cement truck, which we would have been between.

The fire-department chief surveying the scene and my car said, 'You were lucky to be in that model 5 Series BMW, sir. About the best car made, especially for side-impact protection.'

Our guardian angel had stepped in. Helped by a BMW E39 530d Touring, which was then rebuilt as new.

Here is a 53mph (83 km/h) crash of a 3 Series into a stationary 5 Series E39 organized by the Institute of Traffic Accident Investigators.

Right: A BMW X Series
in a 24-hour endurance
race. Following pages:
The BMW 650i in snow.

23

HOLD THAT ROAD

This is a BMW in Dubai in a 24-hour race in 2022. It certainly looks the
business. And on the next page is another negotiating ice and drifting snow.

Road-holding is a BMW speciality. But it wasn't always so, especially in
ice and snow. When I was in the US we would have heavy winter snow
where I lived. But I had a front-wheel-drive Saab 900 Turbo. It stuck to
the road as well as a four-wheel and I soon took that for granted.

Four years later, I moved back to England, first selling my Saab
because I wouldn't get much for a left-hand-drive over the pond. I
bought a BMW 325i. So much smoother, especially through the gears.
And, like the Saab, I soon took that for granted too.

I was now living in the middle of the lovely Shropshire countryside.
Early one morning, I looked out of the window and saw thick snow
everywhere. I hadn't seen any snow since returning. I didn't give what
lay ahead a second thought. I had to attend an important meeting in
Wolverhampton that morning. In fact, I would be chairing it.

My rear-wheel-drive BMW was a bit slippery at first, but I managed to
keep it going. Eventually I reached a modest hill.

I would have chaired that meeting had I kept the Saab.

Later that year I was in Germany. It was 1989, and I was driving a
BMW 325X, a car that was then unavailable in the UK. The change was
sensational. I would have made that meeting had I been in an X.

The other thing about holding the road that is not often mentioned is
the driver holding concentration. For some reason it is easier to do that
driving a BMW, especially an X. But maybe not for 24 hours.

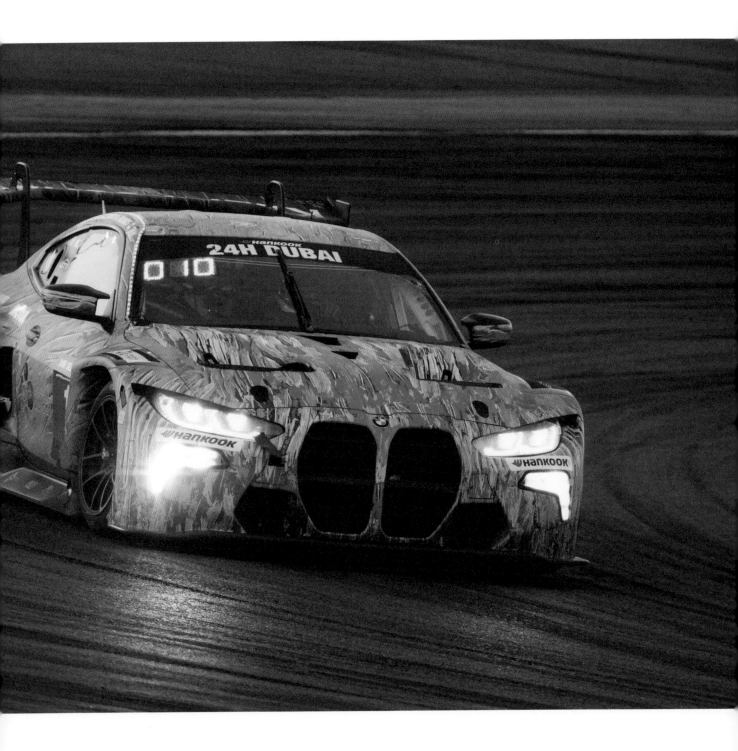

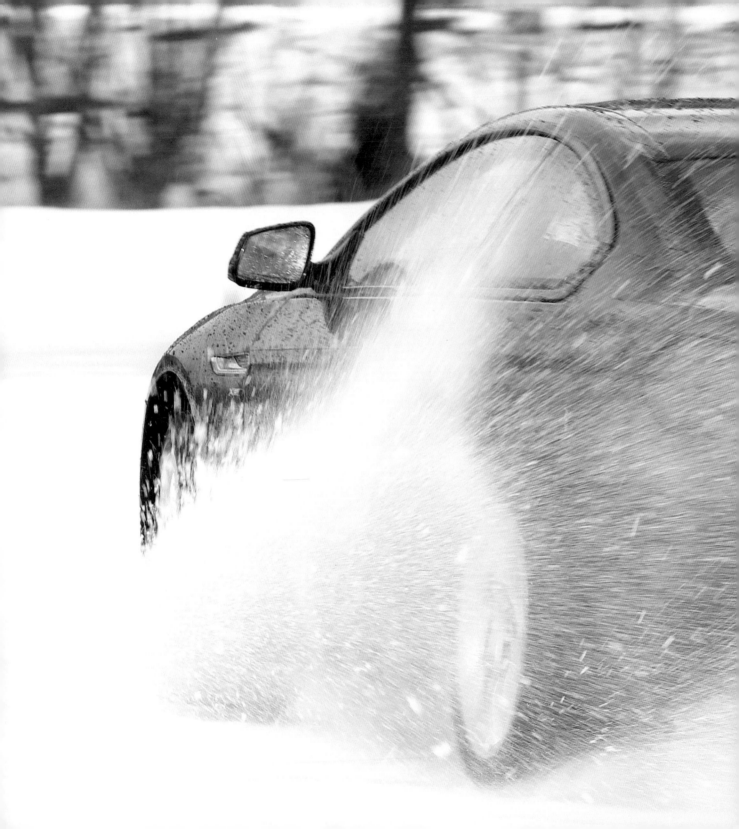

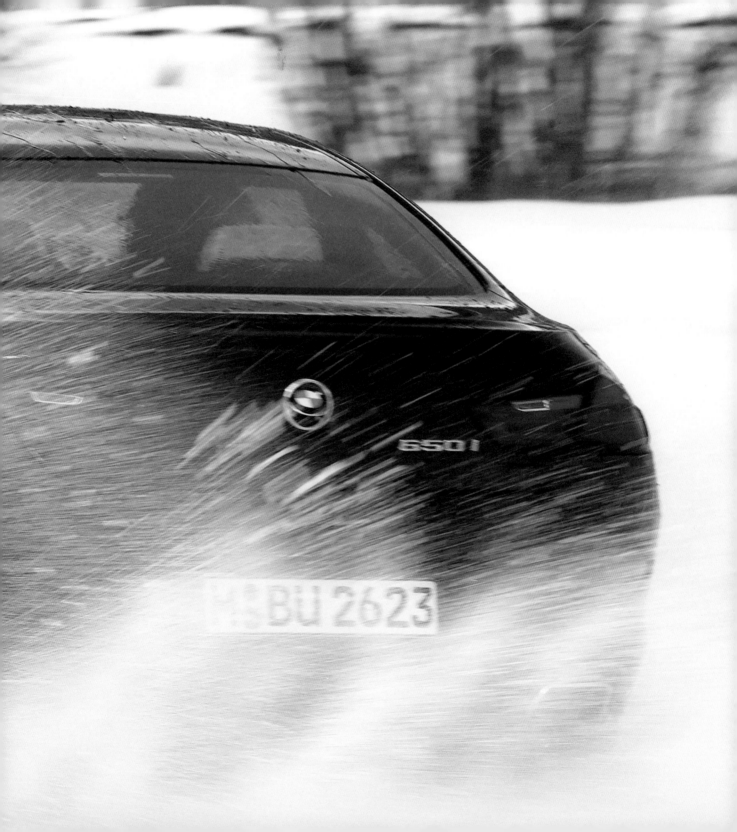

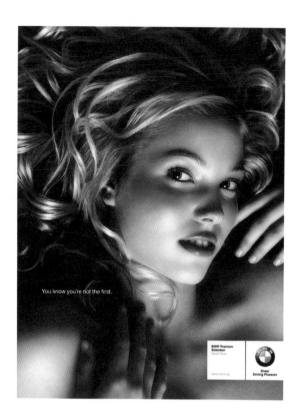

You know you're not the first.

BMW Premium
Selection
Used Cars

www.bmw.gr

Sheer
Driving Pleasure

24

BMW ADS

The Wall Street Journal, usually a rather solemn newspaper, carried this headline on 13 August 2013:

BMW Drivers Really Are Jerks, Studies Find

Based on research in the US and UK, the study the *WSJ* was referring to maintained that BMW drivers were less likely to stop for someone entering a crossing, were more aggressive in their driving, appeared more confident in their knowledge and were likely to be abrupt and demanding. Oh, yes. They also tended to work in business, finance or consulting. In other words, people likely to read the *WSJ*.

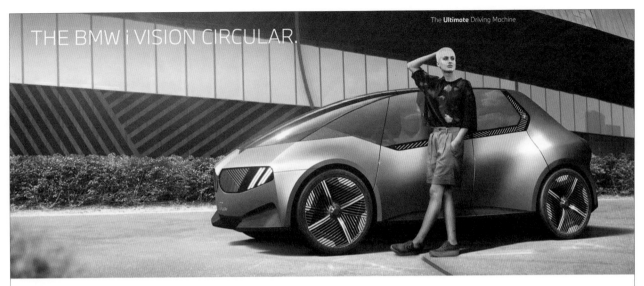

THE BMW i VISION CIRCULAR.

EXPLORE THE JOY OF CIRCULARITY.

The BMW i Vision Circular represents the BMW Group's project to become the most sustainable manufacturer for individual premium mobility. Through the entire process of design, development and manufacture, the vision vehicle is conceived in line with the principles of the circular economy. The creative vision shows a view of a compact, fully electric vehicle with a focus on sustainability and luxury for the year 2040.

It is true that BMW in the past did play on their appeal to young thrusting drivers, mainly male. This prehistoric ad made for BMW in Greece (opposite, above) is an extreme example, but not unusual for its time.

Climate change may have played a key part in realigning BMW but, just as importantly, the owners of their cars no longer tend to be typecast, as seen in this 2022 ad (above). Today, BMW advertising is to be commended for its leadership in foregrounding sustainability as well as being non-sexist.

Opposite, above: Old, sexist BMW advertising.
Above: New, less sexist BMW advertising.

25

BREAKDOWN BMW

I own three classic cars, and when they need attention those who aren't very interested in automobiles assume it's just because the sick car is elderly. There may be a little truth in that but, for the most part, it's because even when the car was new, it was more likely to break down than a modern car.

Years ago, it was quite normal to test-drive a new car around for a couple of weeks, not far from home, fixing things as they went wrong until you felt the time had come for the car to head out for, say, that vacation.

I love this picture taken at the Hamburg Motor Classics Fair of a tableau featuring a 'broken-down' BMW 1800 being repaired by a dummy. I think it's a dummy. The empty bottle of pilsner is a great touch, and would have provided some relief when fixing what looks like crankshaft trouble.

Thankfully, crankshaft trouble is very unusual in a BMW. Even one from the 1960s.

'Broken-down BMW', an 1800 Neue Klasse set up at the Hamburg Motor Classics Fair, 2017.

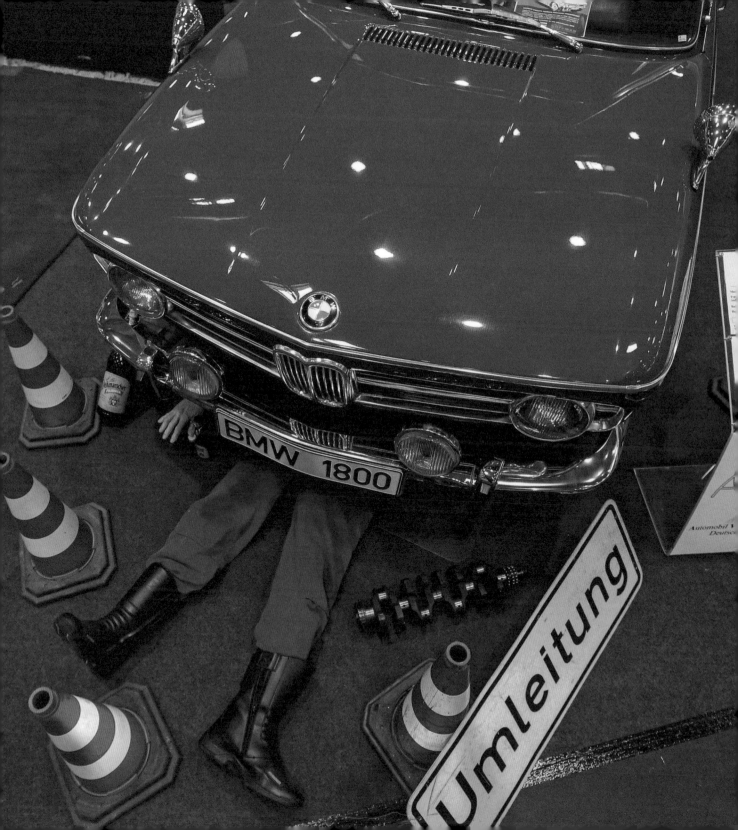

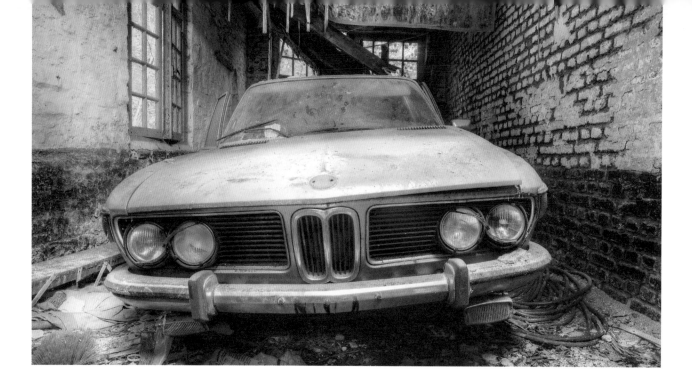

26

ABANDONED BMW

You may not agree, but I do think there are few more compelling images in this book than this photograph of a long-abandoned New Six sedan, rotting away somewhere in Belgium.

This elegant car, produced from 1968–1977, had many engine iterations, with powerplants ranging from 2.5 to 3.3 litres; all, as the series name denotes, were straight sixes. The bodywork was designed by Wilhelm Hofmeister, inventor of the famous BMW Hofmeister kink – more of that later – with the odd Italian touch from Bertone and Michelotti here and there.

And here is a restored Neue Klasse Six, perhaps from a little later in the run. The only things I'm not too sure about are the road wheels.

A characteristic of both cars, abandoned or not, is the single door mirror, a feature that seems to have disappeared from today's automobiles. A case of not noticing until it's gone.

Opposite, above: Abandoned BMW Neue Klasse Six in a garage. Opposite, below: A gleaming restored New Six.

27

THE DESIGNERS

BMW design and engineering were always synonymous with one another, with form following function. Many BMW automotive designer names spring to mind, such as Fritz Fiedler, Wilhelm Hofmeister, Peter Szymanowski, Paul Bracq, Claus Luthe and Joji Nagashima.

Luthe, speaking about his design of the hit E30 3 Series, such as this 1993 318i Touring Estate, said: 'To maintain our tradition, we do not need "way out" designs. The important (thing) is continuity. It is essential that we build a lasting image of what a BMW is and not be swayed by ever-changing fashion trends.'

But the BMW design ethic was to change, and radically, in 1999 thanks to the arrival of the American designer Chris Bangle. A compelling speaker and promoter of new ideas, Bangle regarded the leading architect of post-modernism, Frank Gehry, as his guiding light. Bangle planned to move away from BMW's form-follows-function philosophy, and instead celebrate 'expressing power in a car's design'.

The classic BMW approach was first dumped with Bangle's redesign of the 7 Series E65, seen on page 70 at its Dubai launch in 2001. The US magazine *Time* called it one of 'the worst 50 cars of all time'. The introduction of the then-baffling iDrive at the same time did not help.

BMW E30 3 Series
Touring Estate.

The irony in all this was that the professed abandonment of form following function was only made possible by a step-change *in* function. Unless a panel was shaped by hand, as with a pricey hand-built car, it had always required multiple pressings to make compound curves, and that was rather expensive. But a new BMW technology now made it possible to press in 3D, and that meant one press instead of several. So you could have all the swoops and curves you liked at no extra cost.

The irony continued. Despite *Time*'s view, Bangle's new 7 Series sold better than any of its predecessors. Indeed, it was under Bangle's design direction that BMW overtook Mercedes in the sale of luxury brands worldwide.

Today's BMWs have stepped back somewhat from Bangle's influence, but the change in design philosophy between pre- and post-Bangle cars can still be seen filtering through. And despite digital 3D modelling and virtual reality, full-size mock-ups are still sculptured in clay. Because what a design actually feels like can only really be judged by the touch of a human hand.

Left: Chris Bangle's 7 Series E65. Opposite: Clay model of the 1 Series Coupé, BMW Museum, Munich.

28

ART CAR

In 1975 the racing driver Hervé Poulain asked his friend, the American artist Alexander Calder, to paint the BMW he would race in the Le Mans 24 Hours race. That was appropriate, seeing as Calder had made his name making mobile sculptures. Since then, many well-known artists have been invited by BMW to decorate their cars, including Andy Warhol, Robert Rauschenberg, Frank Stella and Roy Lichtenstein. On one occasion a BMW itself was used to make an artwork. In 2009 Robin Rhode used a Z4 with paint on its tyres to drive over a giant canvas again and again. Jackson Pollock on four wheels.

BMW's Art Cars have been shown in many public spaces, such as New York's Grand Central Terminal and the Los Angeles County Museum of Art. But the focus has mostly been on the US for artists and exhibitions, because therein lies BMW's most profitable marketplace.

BMW drivers tend to be more interested in edgy modern art than drivers of other cars. Except maybe Tesla drivers.

Here is a striking image of the front end of an M850i Gran Coupé, decorated by controversial American artist Jeff Koons in 2022. Only 99 are being sold, so hurry. If you cannot get hold of one, you can order limited-edition miniatures of the Art Cars, complete with their booklets, from your BMW dealer. Including the Jeff Koons. A snip at $145 each.

The Jeff Koons-designed M850i Gran Coupé, 2022.

29

THE ICONIC LOGO

BMW is up there with Audi, Mercedes, Rolex, Omega and VW in having a simple and striking logo, so noticing subtle changes to the famous blue and white roundel is not as easy as it first appears.

It is often thought that the BMW logo was inspired by a spinning propeller, in homage to BMW's aero-engine history. That isn't the case, although it should be, seeing as the legend was encouraged by BMW themselves in 1929, when they ran an advertisement with a rotating propeller showing through the logo.

Actually, the shape dates back to a black ring used by BMW's predecessor, Rapp Motorenwerke, while the blue and white quarters were introduced towards the end of the First World War. They are the historic colours of the Wittelsbach family, who supplied the dukes and kings of Bavaria for centuries.

In this collection of BMW logos, you can see how its design subtly developed, from top left to bottom right. The lower two are the most recent and the difference seems hardly worth making.

But on this rusting beauty, which may be the remains of a 1934 BMW 315 Sport Roadster, the letters are closer together than any in the collection.

With the BMW M1 from the late 1970s, it could be a case of that old song, 'New York, New York' (so good they badged it twice). Without the punchline, of course, 'All the scandal and the vice'.

Although, come to think of it, the M1 was a rather racy piece of kit.

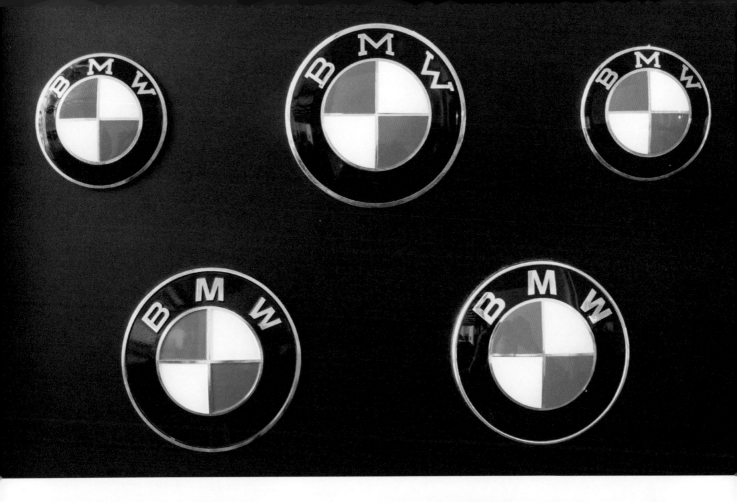

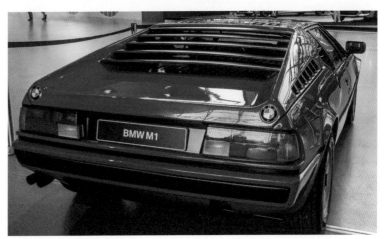

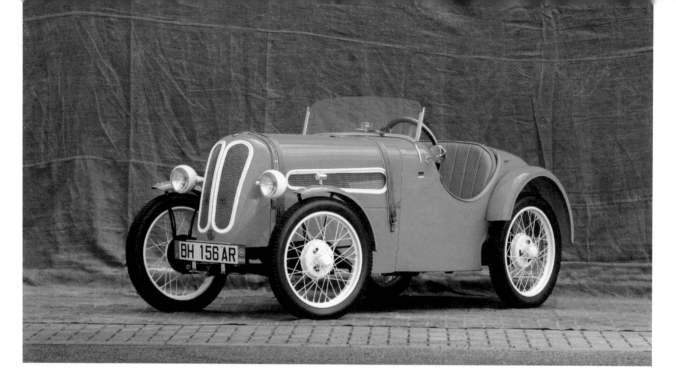

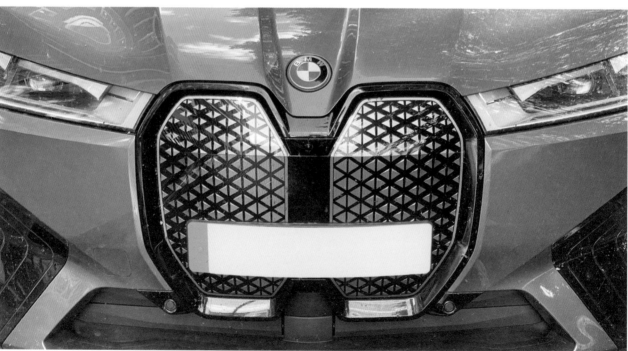

30

THOSE KIDNEYS

When you think about it, how many of today's automobiles sport a radiator grille immediately telling you the brand?

Rolls-Royce and BMW spring to mind, but then it gets more difficult. Audi have their Olympic-type rings, Citroën an inverted V, Volvo a diagonal bar and so on, but these are mere decorations applied to a nondescript background. Those double kidneys are an immediate identifier of a BMW, even though the design has been much reimagined over the years. You can clock it's a BMW half a mile off, just from its radiator.

The double kidney goes back a long way. Here is a 1931 BMW (Dixi) Sport. And at the other end of history, a 2022 BMW iXDrive50.

There is no cooling air flowing through the all-electric iXDrive 50, so this is a stick-on. And that is odd for BMW, because in the modernist style, made popular by that famous between-the-wars German design school the Bauhaus, led by the architect Walter Gropius, BMW doesn't do meaningless decoration.

I suppose they could go the full Tesla and have no grille at all. But then, a BMW double-kidney radiator is the company's signature image.

What to do for an all-electric age? Best to send any advice, accompanied by a drawing, to Concepts and Visions, BMW Group, Petuelring, 130 D-80809, Munich, Germany. You could also contact bmwgroupdesignworks.com for good measure.

While you're at it, advise them on Rolls-Royce, seeing as they have a similar problem, and BMW are responsible for them too.

Opposite, above: 1931 BMW Dixi Sport Type 600. Opposite, below: 2022 BMW iXDrive50.

31

THE FRONT END

We've talked about the kidneys, but it doesn't end there. The front end of a BMW has, more often than not, made the car look a little menacing, a little intimidating, an effect not achieved from other angles.

This 2020 M8 Gran Coupé (below) is an example. How many times have you seen something like this in your rear-view mirror? In green it looks even more like a monster ready to eat you up. The same could be said for this black 1940 327 Cabriolet (opposite).

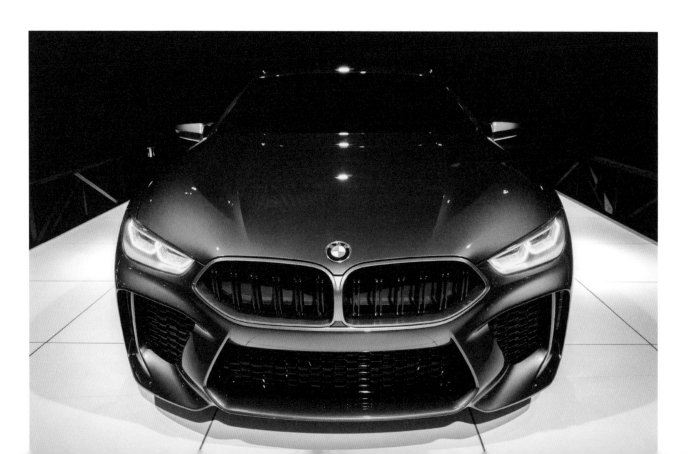

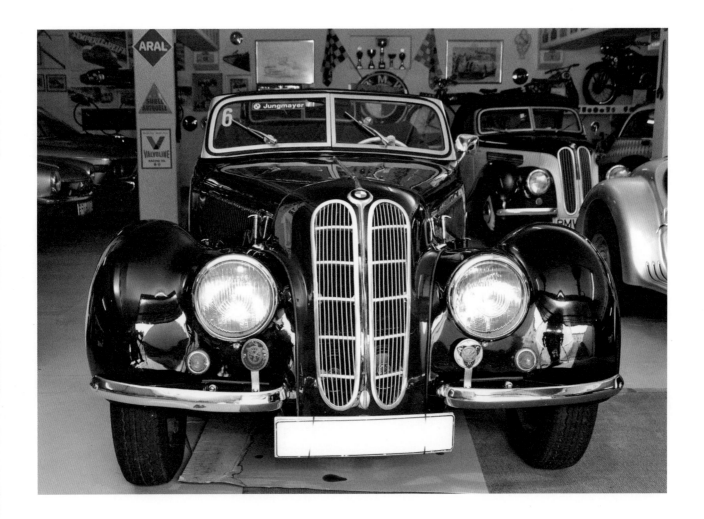

Of course, many automobile manufacturers design the front end to make their cars look faster than they actually are. Yet you would think in today's world, when car speed doesn't just mean increasing accidents but also burning up the planet, making it look fast would be a no-no. Apparently not.

So can we ever see BMW embracing slow and taking design inspiration from, say, the Isetta bubble car of yore?

You know the answer. And you also know that if the front end of a BMW makes the car look fast, you can bet the farm on it being so.

Opposite: 2020 M8 Gran Coupé. Above: 1940 327 Cabriolet.

32

THE KINKY SIDE

What first identifies a BMW from the side?

Answer: the Hofmeister kink, as seen on the rear windows of this
3.0 CSi from 1972 (opposite). The BMW roundel fits superbly in the
space the reverse kink provides, deliberately drawing attention,
some say, to the rear-wheel-drive capabilities of this sports coupé.

Wilhelm Hofmeister, head of design at BMW from 1955–1970,
introduced this feature in 1961 with the advent of the BMW Neue
Klasse models.

There had been kinks before, such as on this 1949 Cadillac 61 Club
Coupé (above), but it was only at BMW that the kink would be kept for
every sedan and coupé in the future. Thus did the Hofmeister kink take
its place alongside the blue and white roundel and the double kidneys
as defining a BMW.

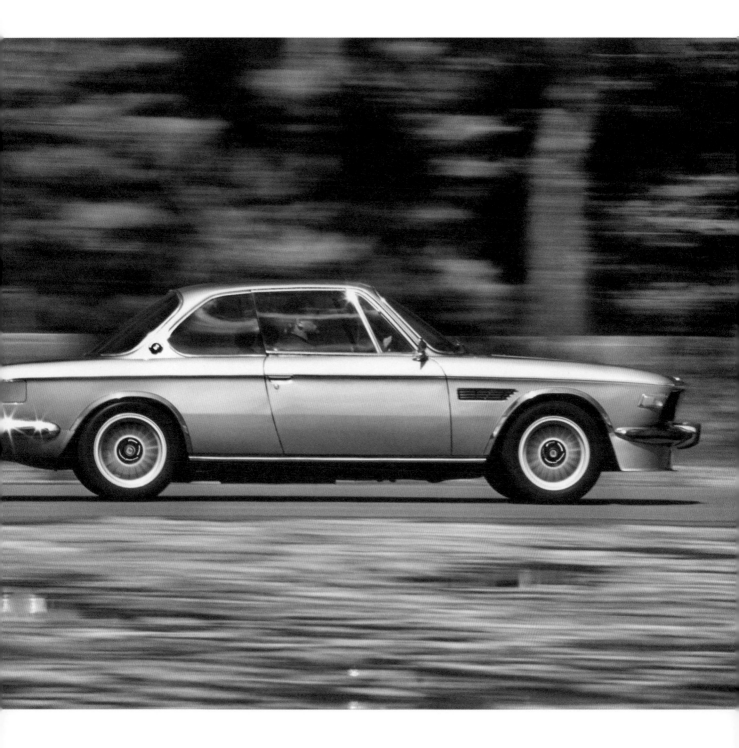

33

THE REAR END

As mentioned earlier, *Time* magazine was once rather rude about Chris Bangle's E65 7 Series. It was unkindly dubbed the 'Bangle Butt', but it was certainly less cluttered than the backside of this 2018 i8 plug-in hybrid, where there is nowhere for the eye to rest.

So the intriguing question is, why didn't BMW get round to developing a defining feature for its rear ends? After all, it did it for its front ends with the superb double kidneys and for its sides with its elegant Hofmeister kink.

It's odd, isn't it? Especially when, as a driver, your abiding memory of a BMW is its rear end fast disappearing in front of you.

The i8 plug-in
hybrid sports car.

34

FROM THE TOP

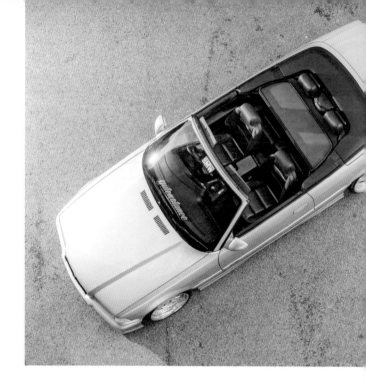

Unless you are a deity, car designs are not seen, or designed to be seen, from on high.

Yet when we can take a peek, a view from the top will tell us more about a car's overall design than from any other angle, short of standing in a hydraulic lift underneath it and looking up. But then you would need to know quite a bit about automobile engineering.

This 3 Series E36 M convertible (above), introduced in 1986, is arguably one of the most simply elegant cars BMW ever designed. Good convertibles, of course, possess a timeless quality, and this one doesn't seem to have a line out of place.

And then there is this 2004 car designed to run on hydrogen (opposite). You won't be buying one any time soon, because this was only a concept, made when BMW, early in the green game, were thinking about how to get away from fossil fuel. Sadly, hydrogen didn't happen for BMW or anyone else really, so nearly 20 years later, this extraordinary beast is something of a fossil itself.

Unlike the 1986 convertible.

Above: The 1986 E36 M Convertible. Opposite: 2004 H2R concept car.

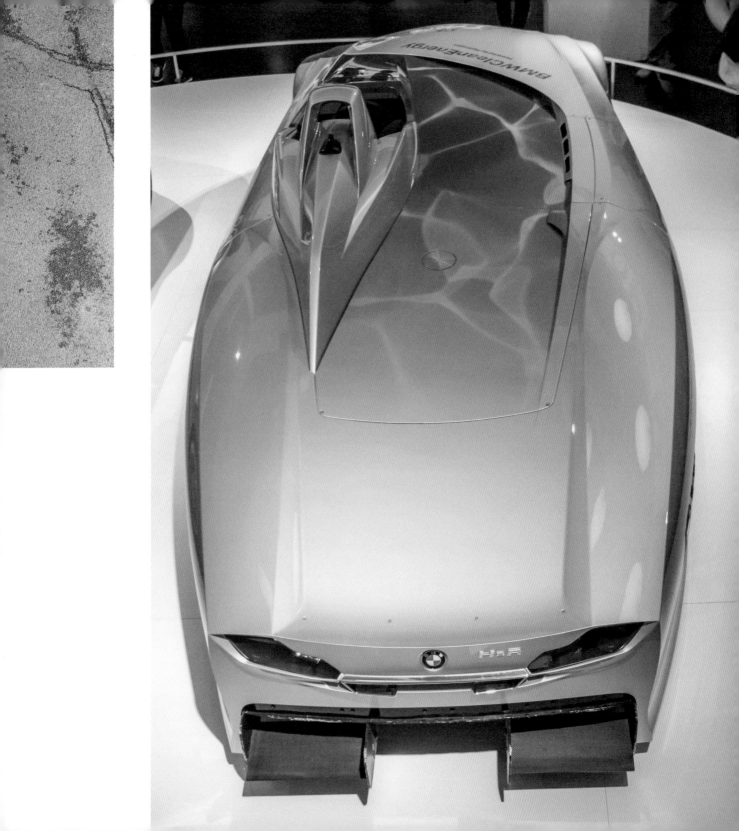

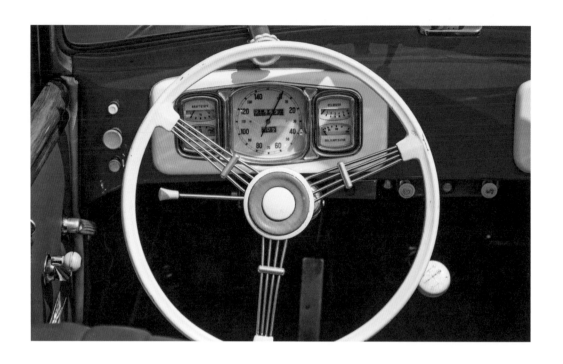

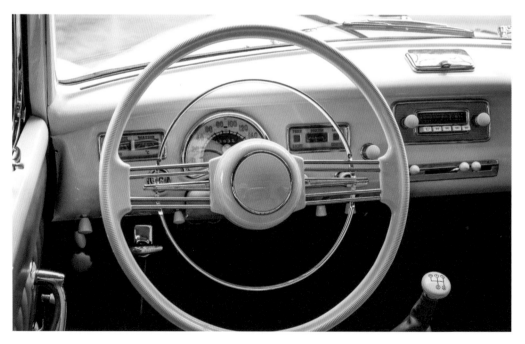

35

THE COCKPIT

As with all makes of car, the BMW cockpit has morphed over the post-war years, thanks to changes in technology and safety regulations. And, of course, fashion.

I think the 1950s and 1960s are the most interesting when it comes to BMW's cockpit design, not least because they mirror Germany's time of transition. The 1952 327 drophead with the brown and white wheel has pre-war dashboard instruments married with that classic 1950s sign of sophistication, a white steering wheel.

The all-white cockpit of the 1955 502 drophead is pure post-war West German BMW: 1950s instrument panel, push-button radio and a steering wheel sporting that icon of the age, a horn ring. The 502 was the fastest sedan in Germany at the time.

Opposite, above:
Cabin of the 1952 BMW
327. Opposite, below:
Cabin of the 1955 502
drophead.

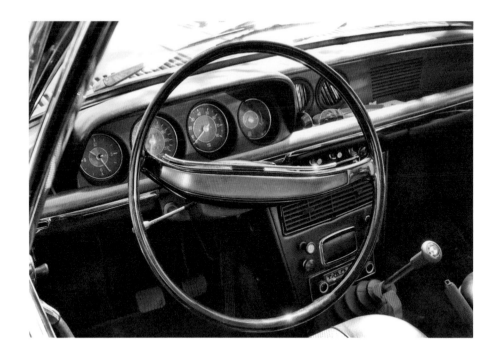

The 1966 2000C displays a red-line tachometer and slick veneer that even extends to the dished steering wheel. Flares and mini-skirts may be off-camera but at least the shades have been left on the shelf for period effect.

The 1974 2002 Tii was the company's first smash-hit sports sedan. It propelled BMW from a minor European car maker to a real player, snapping at the heels of the mighty VW and Mercedes groups. The cockpit is 1970s minimalist, a deadpan understatement of the car's eye-popping performance. This model was my first BMW. Totally brilliant.

By 1999 BMW had introduced post-modern to cockpits, this Z8 being a fine example of going faster in style.

Today's fashion for functionality with frills is celebrated in this i8 Roadster. Its bravely sculpted cockpit could have been moulded from silicone rubber.

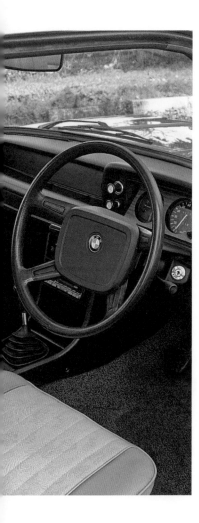

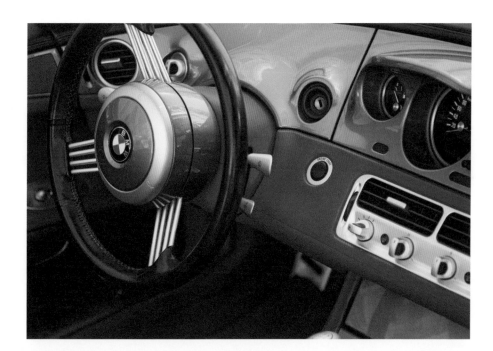

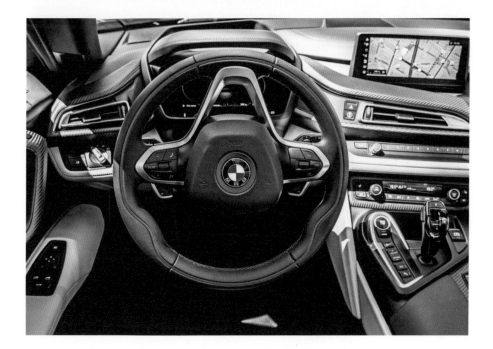

Clockwise from above
left: 1966 2000C; 1974
2002 Tii; 1999 Z8; i8
Roadster.

Above: 2000 3 Series
Convertible. Opposite:
8 Series Convertible.

36

CONVERTIBLE COOL

As I've said, there is something timeless about a cool, four-seater
drophead, or convertible, especially a BMW such as this E46 3 Series
from the millennial year.

A psychologist might say that making time stand still is why the
convertible is so popular with us older drivers. Well, that's an interesting
thought, although we may reply that it's only because our convertible
provides a sense of freedom. Yeah, right.

Why does a convertible evoke jealousy? Because it signals not having
to go to work. Perhaps the driver is a trust-fund dude, or more likely a
platinum pensioner. How about a lady who lunches? She would be just
the thing behind the wheel of this green beauty, leaving us green with
envy as she purrs by.

BMW convertibles are deliberately understated as convertibles go,
although less so now, especially where bling sells bigger. Should you
yearn to swan around in this black 8 Series convertible, people may
think you are a gangster, a person of interest to the tax authorities or
both. Actually, you are a harmless retired dentist on vacation who has
rented this car at the airport.

37

BACK SEAT DRIVER

Several years ago, I attended a private view at a London art gallery of the work of a famous German Jewish artist, then in his nineties. He and his family had escaped his homeland just before the outbreak of the Second World War and he had lived and painted in England ever since. Now the German ambassador was about to present him with his original country's passport and its highest civilian award. Then the ambassador would declare the exhibition open.

When the chauffeur-driven diplomatic car drew up outside the gallery, out of which stepped the ambassador, I was less taken aback by the flashbulbs and the general celebrity hubbub than by the car itself. It was a black BMW limousine.

If it had been an S-Class Mercedes, I wouldn't have given it a second thought.

Why was that? Well, we don't think of being driven around in a BMW. Because it is the Ultimate Driving Machine, we assume we should be behind the wheel ourselves.

By the way, the ambassadorial car was flanked by four police motorcycles. You can guess what make they were, but for some reason I took that for granted.

But if you had a chauffeur for your BMW, how long would it be before you become a back seat driver?

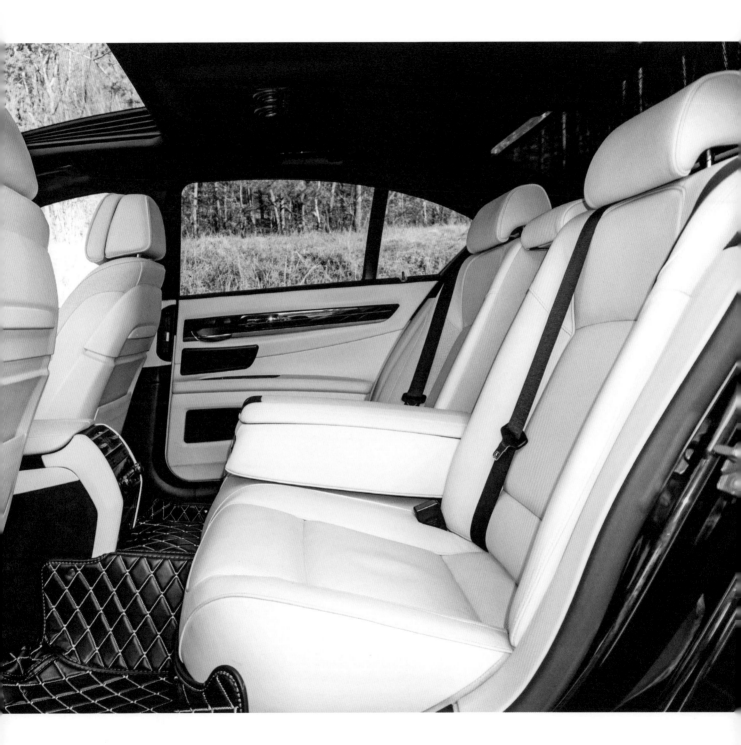

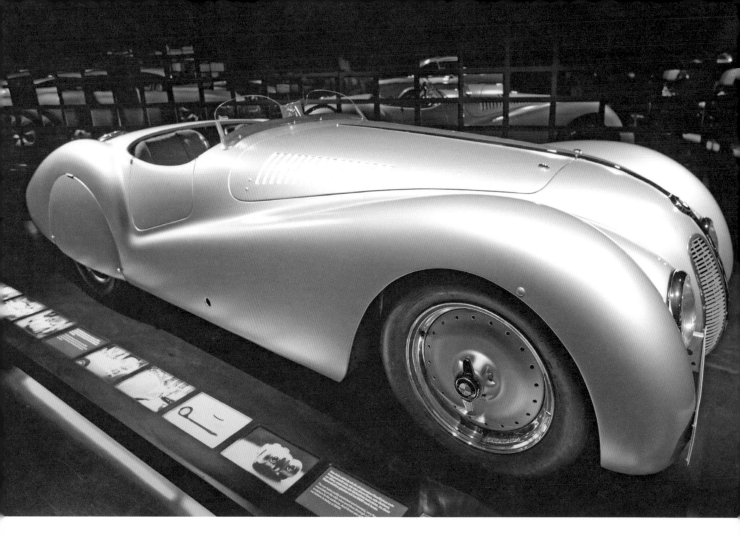

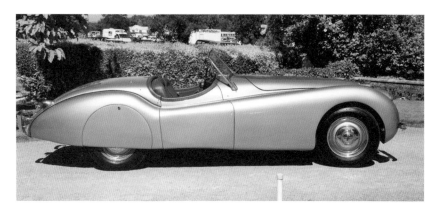

38

CLEAN LINES

BMW has always aimed at maintaining clean lines and keeping decoration to a minimum. When they wanted decoration, they would ask a famous artist to do their stuff on one of their cars.

The standard for clean, unadulterated lines was set long ago. Here is a 1939 BMW 328 Mille Miglia Roadster (opposite, above). It was designed by Wilhelm Kaiser in 1937.

Actually, this car is an exact copy, made for the BMW Museum. The original found itself in the USSR after the Second World War and was taken as reparations. It was then owned by the designer of the Russian MiG warplanes. In 1972, his son traded it in for a new Lada. Yes, really. The original is now in a private collection.

The lines of this car were so well regarded that after the war, Jaguar took one look at it and so we have the Jaguar XK 120 Roadster as seen here (opposite, below right). Designed by William Heynes, the first production XK 120 was delivered to Clark Gable in 1949.

All a long time ago. But that doesn't matter, because clean lines and good design are timeless.

Opposite, above: The 1939 328 Mille Miglia Roadster. Opposite, below left: BMW door handle. Opposite, right: The Jaguar XK 120 Roadster.

39

THE WHEELS

Below left: Wheel on a 1937 327 Cabriolet. Below right: 1958 507 Roadster. Opposite: Recent wheel showing brake callipers/rotor.

It is great when an automobile manufacturer always has its emblem on the road wheels of its cars. Not all do, and I guess it helps when you have a circular logo. You'd expect it to spin round.

The BMW logo denotes authenticity, which is a long way from the world of hub caps, non-standard wheel trims and alloys, liberally deployed on lesser marques.

The yellow wheel is on a 1937 327 Cabriolet, the black one, a 1958 507 Roadster.

Much more recently, the fashion has gone against covering up what is behind the wheel but rather displaying it prominently. This M car draws attention to the formidable brake callipers, which are painted red so you don't miss the point. The point being that here is an automobile that must be blisteringly fast, if that is what it takes to slow it down.

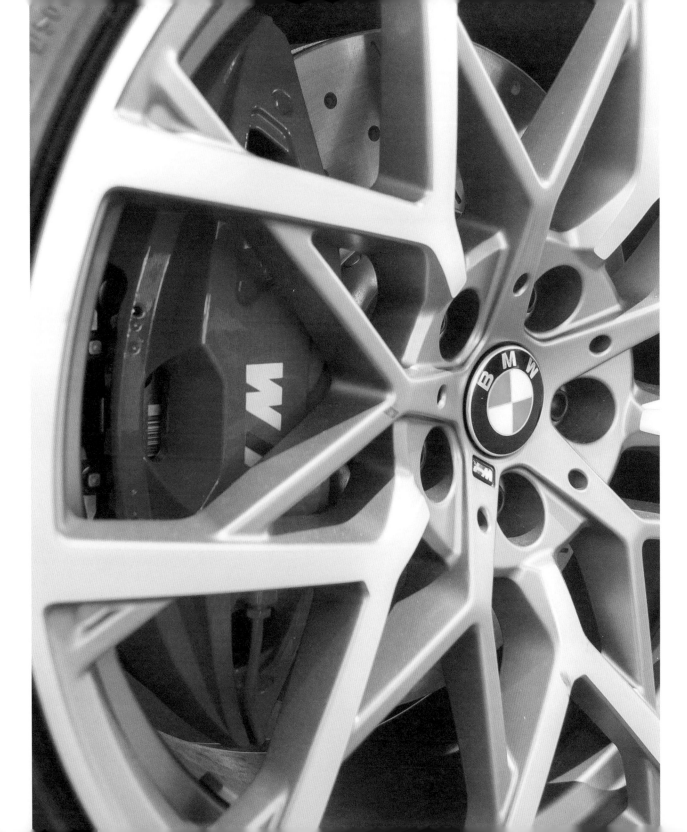

40

HOMAGE TO SPEED

In the old days, men and boys, usually interchangeable, would brag about how fast their car was, how many cigarettes they smoked, how much liquor they could hold and how many women they had slept with.

BMW was into the first for a time. Just look at their advertisements from the 1970s. But that was all in the distant past and a long way from the cool company BMW is today. So it was rather a surprise when in 2016 an M2 Coupé was rebodied and showcased in Italy as the BMW 2002 Hommage Concept and later that year in California as the BMW 2002 Hommage Turbomeister Concept.

Why Turbomeister? Well, Jägermeister, the makers of one of Germany's most popular alcoholic beverages, had a history of sponsoring racing events and they sponsored this car.

And why a 1970s BMW 2002? The rebodied M2 was built in homage to the turbo version, launched in 1973 as Europe's and BMW's first turbocharged production car.

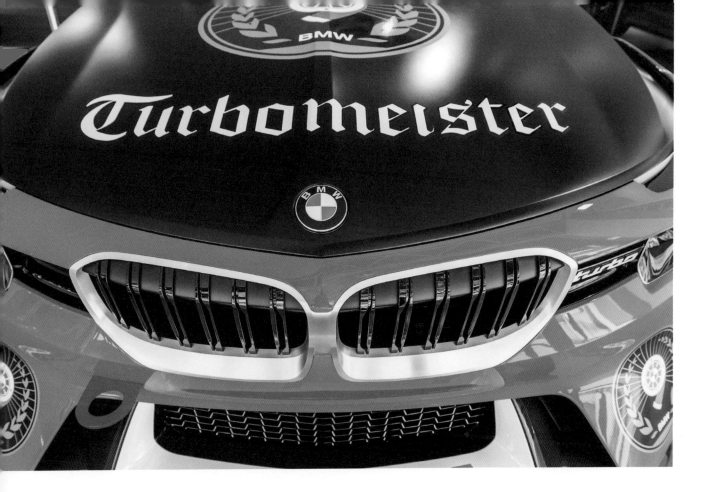

That car was controversial. It triggered a heated debate in the Bundestag, West Germany's parliament. BMW was encouraging aggressive, fast driving, not least because the word 'TURBO' was displayed on the front spoiler of this model in mirror image.

The message was clear. When other drivers glanced in their rear-view mirror and saw a BMW 2002 Turbo bearing down on them, they knew they were being bullied out the way and should move over PDQ. This was a car for hooligans.

BMW had had their knuckles rapped. They dropped the embarrassing lettering, and that was a good thing, because we already know a BMW is a fast car, so we don't really need an Hommage Turbomeister years later to remind us of the 2002 Turbo, even though most of us had forgotten.

Opposite: 1973 BMW 2002 Turbo. Above: The Turbomeister BMW concept car.

41

THE IDRIVE

When the cleverly named iDrive was introduced by BMW in 2001, first on the 7 Series limo, there was much wailing and gnashing of teeth throughout the BMW community.

BMW's iDrive put all the car's cabin control functions in one place. It used a rotary wheel right next to the gear lever. Your choice, made by spinning the wheel, was shown on a dashboard display panel.

The BMW community, all of whom thought they were smart, seeing as a BMW was their car of choice, were faced with trying to get their head around a baffling system, distracting for the driver and fiddly to boot. The driver was required to look away from the road to ensure the wheel was selecting the right menu or, God forbid, the sub-menu on the screen. And they thought, quite naturally: 'If even I cannot drive this, how can anyone else?'

So the geeks had to listen, and BMW started developing a more intuitive and user-friendly iDrive.

As with most new technologies, people eventually get used to them and even acknowledge their benefits. So much so that, as it is for many other BMW innovations, the copycats followed. Now Audi has its MMI and Mercedes its COMAND, both of which are close cousins of BMW's iDrive.

As for the alternatives – touch-screen systems – they are now regarded as more distracting and thus less safe.

42

THE COLOUR

If you had to decide, what would it be? Here are four to choose from: blue, green, red and a darker blue, although in that brochure the salesperson has given you to take home, the colours have much fancier names.

So you are still in the showroom and the salesperson says, 'Yeah, there is quite a long waiting list. But hey, why not that dark grey demonstrator over there? You can drive that away tomorrow.'

Your partner may have different ideas when you get it home. 'Why grey? I really liked the white ones.'

'Well, there was at least a three-month waiting list for all the other colours. And they've taken a thousand dollars off this one.'

'Fine. So now we have a grey car on the driveway for the next three years for $40K instead of a white car for $41K.'

A parade of colourful BMWs.

Actually, the colour of a BMW is not important when you get behind the wheel, especially when you've never driven a BMW before. The *bella figura* of a BMW is the driving pleasure. Forget the gizmos, the model, the colour. Until you press that loud pedal, sleek anonymity is just fine. The only colours that are important are in that BMW logo.

There are exceptions. Here are some magnificent old-timers – 507s – at a rally in Treffen, Austria. Red, white or blue. Which do you prefer? I'd take any of them, except it would cost a whole lot more than $41,000.

BMW 507s polished to perfection.

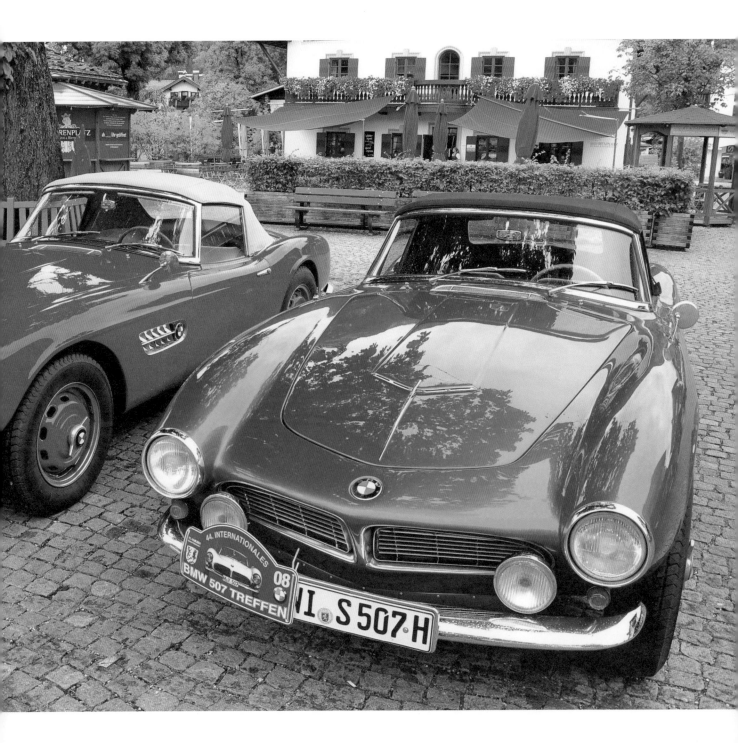

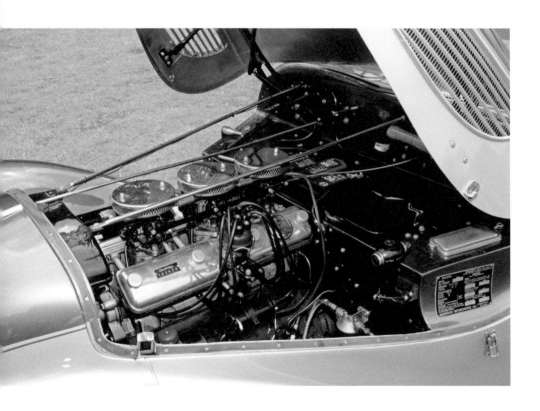

43

THE ENGINES

Germany has resonance when it comes to automobile and engine designers – Karl Benz, Felix Wankel, Rudolf Diesel, Ferdinand Porsche. We should add Fritz Fiedler.

Fiedler's design of a two-litre in-line six-cylinder BMW engine made the motoring world take notice, especially when it charged to victory in the 1940 Mille Miglia. This power plant put BMW on the map, to the extent that a BMW engine would, from then on, be the company's calling card, whether it was an in-line four, in-line six, V8, V10 or V12.

Today, other marques buy in BMW engines. A contemporary example is Range Rover, who fit BMW's 4.4-litre twin turbo V8 to their latest model – for a hefty price, of course.

Here is the engine that made BMW famous. It is the Fiedler 1971cc, fitted here to a 1938 Frazer Nash BMW 327 Cabriolet (far left). Like all subsequent BMW engines, it is beautiful to behold.

The Alpina makeover of the 2002 sport sedan (left) is interesting, if only because the company has added its name to a BMW engine they have rebuilt with the company's blessing. By 1969, the vintage of this engine, the 2002, had been around for less than three years and it was already considered a pocket rocket. Alpina just made it more so.

The 3-litre was built for a 1974 CSL Coupé (following pages, above right). It gave this sleek and powerful model power aplenty. BMW provided a tall rear wing (not allowed in Germany), earning this car the title 'Batmobile'. If the rear wing was not enough, you could pop the hood and feast your eyes on the red ports.

For their best-selling 3 Series, BMW provided this engine, a 330D, for this 2002 E46 car (following pages, below right). BMW diesels established a reputation for longevity and mid-range muscle. There

Previous pages: 1938 Frazer Nash 327/80 Cabriolet engine; Alpina engine. Right, clockwise from top left: X6 Hybrid; 1974 3.0 CSL Coupé; 2002 330D; BMW i4 Sport.

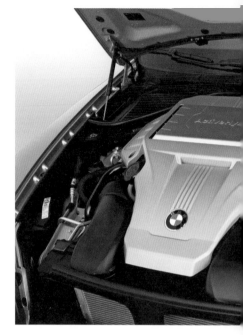

were few cars to challenge the pulling power of a BMW 3-litre twin-turbo six-cylinder diesel, especially on a long motorway incline.

It has to be said that BMW was slow in joining the electric club. Here is their first full hybrid, designed for the X6 crossover (right). It was unveiled at the 2009 Frankfurt Motor Show and at 402hp was the world's most powerful hybrid car. Aimed mainly at American buyers with enough money to display green credentials in luxury, the hybrid X6 used more fuel than its turbo-diesel stablemate.

The i4 Sport (below right) brings us up to date. It looks for all the world like a conventional BMW, but don't be fooled. It is not. It is all-electric. Over a 200,000km (120,000 miles) estimated life, it is designed to have a 45 per cent lower global-warming effect than a comparable contemporary 3 Series. Yet it is no good just looking at the engine, because there isn't much to look at – so here is its skeleton, which explains better.

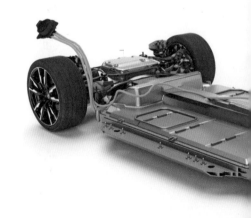

There are two engines, one front, one back, with the batteries in the floorpan between. These can be charged to 80 per cent in 31 minutes. If you're concerned about pedestrians stepping in front of your silent automobile, false engine sounds are broadcast via external speakers when driving slower than 13mph in Europe and 19mph in the US. In the meantime, there is an M version of the i4 Sport, which I will dub the 'BMW Greenspeed'.

What next? A solar-powered i4 Sport?

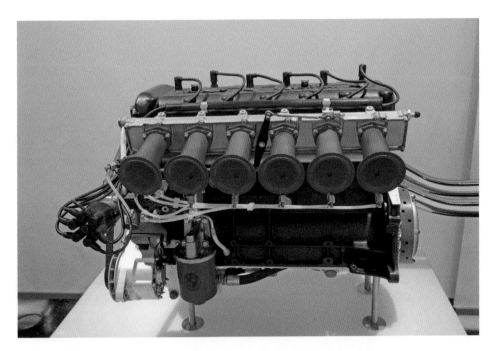

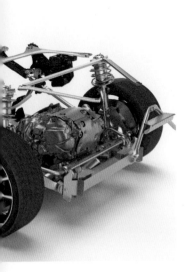

44

SKI BMW

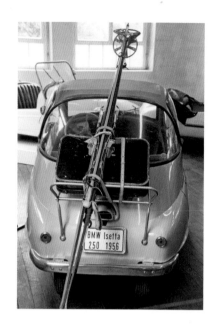

Here is a surreal scene in Courchevel, one of France's fashionable ski resorts.

Instead of a Damian Hirst full-sized shark in a glass container filled with formaldehyde, we have a BMW xDrive. Is this a new addition to BMW's Art Cars collection? Of course not. It is an advertisement to well-heeled international skiers for the xDrive.

'*La technologie 4 mortrices intelligente.*'

Intelligent four-wheel drive is certainly a good idea for driving in snow and ice, although roads to busy ski resorts are normally kept pretty clear nowadays. If weather conditions mean that cannot be achieved, the resort is closed.

Many moons ago, when roads to ski resorts could be a lot more dicey, skiers reached their destination by all sorts of means. VW Beetles and Porsches were good, thanks to the weight of their engines over their rear-wheel drive. Saabs were also popular, thanks to the weight of the engine over their front-wheel drive. Citroen 2CV? No problem. As for North America, any gas-hog on snow tyres with a tombstone dropped in the trunk to keep the back end down could do the job.

But I would like a BMW Isetta 250 from 1956. Complete with antique skiing kit, it would be a hoot driving up to Courchevel.

Above: Isetta 250 with ski equipment strapped on. Opposite: BMW xDrive on display in Courchevel, France.

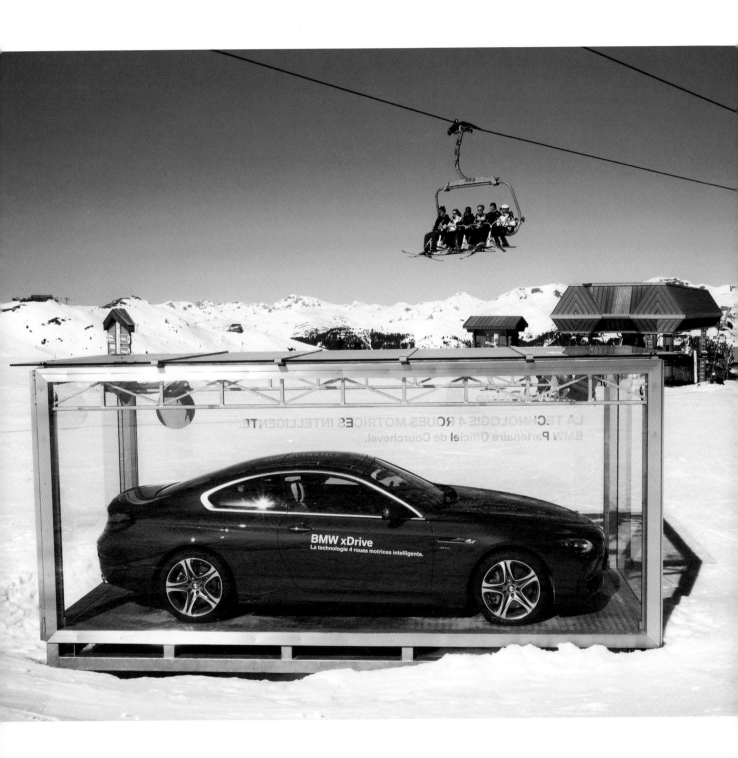

45

BIMMER SPECIALS

Here is a 2009 Alpina B7 Bi-Turbo. Since the 1960s Alpina, an
independent company based in Buchloe, Bavaria, has been offering
BMWs with upgraded engines, suspensions and interiors. Alpina is not
an after-market company, because their processes are part of BMW's
production lines. So Alpina is classed as a car manufacturer in its own right.

 Alpina introduced Switch-Tronic, their much-imitated button gear-
changing on the steering wheel, and lots of other innovations. These
expensive, high-performance yet deliberately understated touring cars
provide a different take on BMW's own M range.

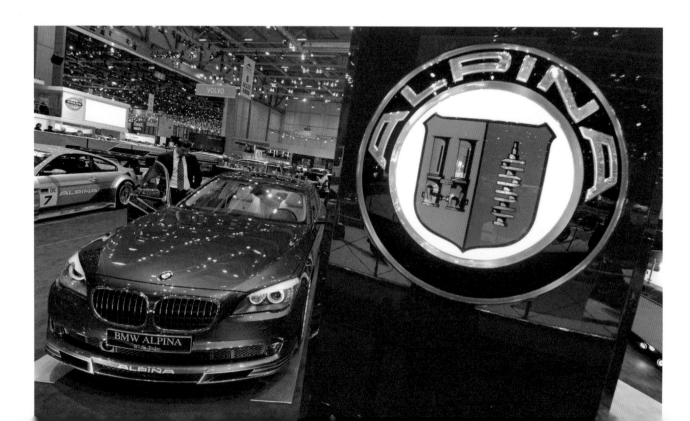

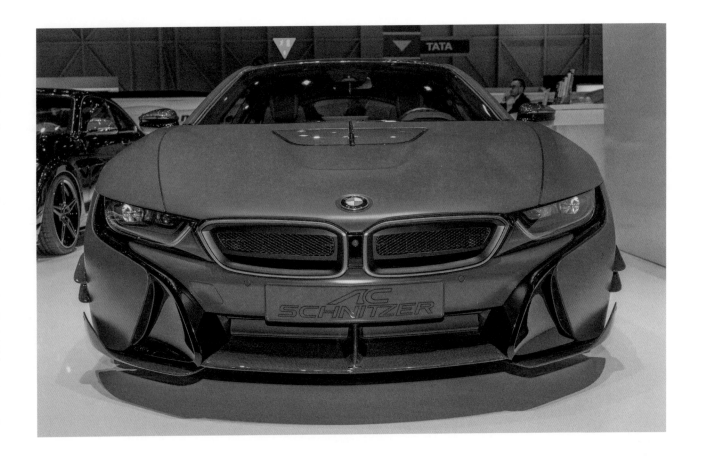

By working with Alpina, BMW pioneered the encouragement of an independent company to create special versions of their cars. That approach would be imitated by others, such as Audi/ABT and Mercedes/Brabus.

In March 2022, BMW announced that it intended to buy Alpina, so the jury is out on what will now happen.

Alpina are not the only company to produce special BMWs. Since 1987, the Aachen-based AC Schnitzer has been offering after-market, performance-tuned BMWs, with bespoke interior fittings made to a customer's requirements. Here is a 2017 AC Schnitzer BMW E8. Pricey, but very special.

Opposite: 2009 Alpina Bi-Turbo. Above: 2017 Schnitzer BMW E8.

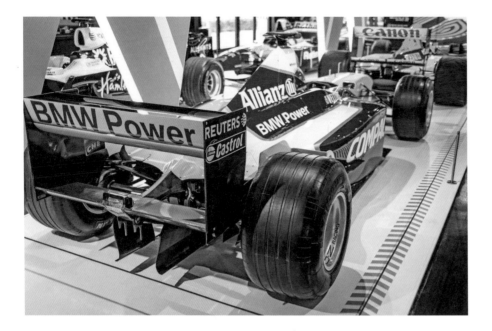

46

RACING AND RALLYING BMW

Once upon a time, BMW loved Formula One. And Formula One loved BMW. Nowadays, BMW no longer concentrate their racing resources there. Why not? They were good at it.

But BMW believe that the massive investment needed to compete in F1 is not worth their resources. Not enough bangs per buck.

So they concentrate on racing versions of their road vehicles, which have, in research terms, a direct connection with the cars their customers actually drive.

Above left: Williams BMW Formula One car, 2021. Above: BMW Team RI L M8 GTE at Daytona, 2020.

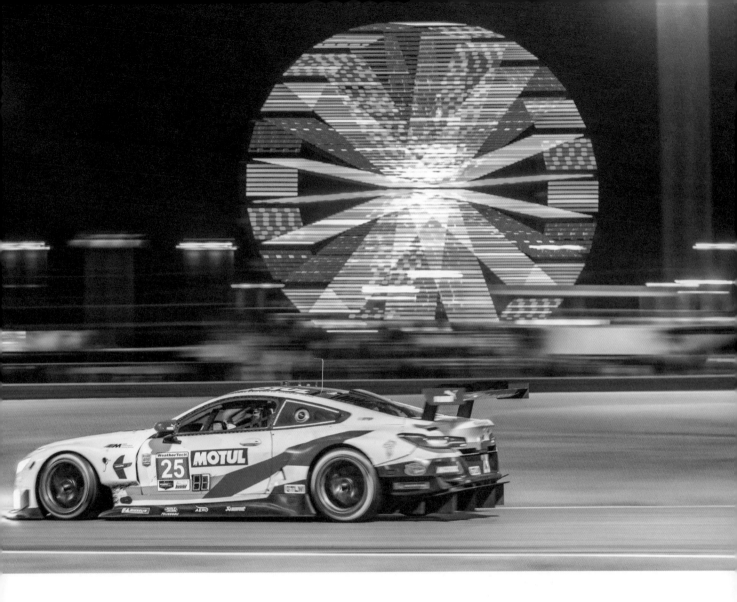

But there is a second reason, I think. F1, although racing all over the world, is very Eurocentric. And BMW makes good profits in markets where F1 is less well known. Such as the US.

So here is the BMW Team RLL M8 GTE racing through the night at the Rolex 24, Daytona Beach, Florida, on 25 January 2020 (above).

And here is a Williams BMW Formula One car (opposite) to remind us that if BMW really wants to, it always can.

BMW's Spartanburg
plant in Greer,
South Carolina.

47

BMW IN AMERICA

Although the first dealership in the US was established in 1975, BMWs have actually been sold in America since 1956.

In 1994 BMW opened a factory – BMW Spartanburg at Greer, South Carolina. BMW Spartanburg would become the company's main manufacturing facility for the global production of the X3, X4, X5, X6 and X7. It would also be the largest BMW factory in the world, when measured by the number of vehicles produced.

The reason these automobiles are built here is because the US is BMW's largest SUV market. In addition, an important export market for BMW Spartanburg is China. All BMW's other models are imported into North America. The key importance of the American market for BMW and its SUVs is clearly demonstrated at Spartanburg.

The name Spartanburg certainly has a German ring to it, although the plant is named after Spartanburg County, within which Greer lies ... and spartan is the last thing BMW's luxury SUVs are.

48

HEADQUARTERS MUNICH

Although BMW nowadays has offices and factories strung across the world, the company has always been associated with the southern German city of Munich, capital of Bavaria.

Overlooking the Olympic Park, and in front of BMW's main factory, stands a tower. This is BMW's global headquarters. The architect was Karl Schwanzer. BMW may have made its reputation on six cylinders, but the building was inspired by a four-cylinder engine, hence its name, the Vierzylinder.

Built from 1968–1972 and opened in time for the Munich Olympics, the giant cylinders were built on the ground and then jacked up to be suspended on the central support tower. With a diameter of 52.3m (172ft), it is an extraordinary piece of engineering, and it was therefore no surprise when in 1999 it was awarded protected historic building status.

Next to the Vierzylinder is Schwanzer's equally striking BMW Museum, inspired by an engine cylinder head.

On the opposite side of the road is BMW Welt (BMW World), the most popular tourist attraction in Bavaria. Opened in 2007, the architects were Coop Himmelb(l)au. Inside this solar-powered building are all BMW's current automobiles as well as their latest Rolls-Royce and Mini models. There are also multimedia displays, a large souvenir store and a restaurant.

The highlight, certainly for those who have come to collect their new car, is a circular elevator platform, which, for all to see and with full theatrical effect, lifts their chosen automobile into the glass exhibition hall from somewhere in the depths below.

Opposite, above:
The BMW headquarters in Munich. Opposite, below. The BMW Welt tourist attraction.

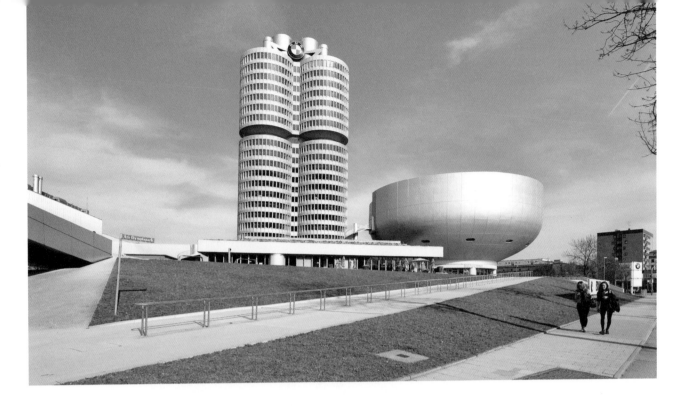

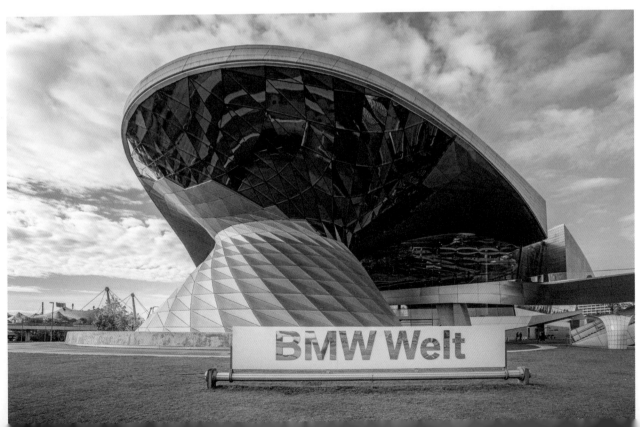

49

THE BMW MUSEUM

For anyone interested in the history of BMW, with examples of the key models the company has made, this has to be the place to visit.

The exhibition starts where this book starts, with BMW's first car, the Austin 7, built on licence as the BMW Dixi. This 1928 model is a 3/15 (following pages, below right).

Not far away, one of the original British-designed Minis is displayed (following pages, left). The first Austin Minis were named Austin 7 in honour of their pre-war predecessors. This car is a 1964 Austin 7 Mini Cooper.

When I visited the museum, it struck me that here stood a reminder that when BMW bought the Mini brand they had bought the brand that had given birth to their first car.

The BMW Car Museum, Munich.

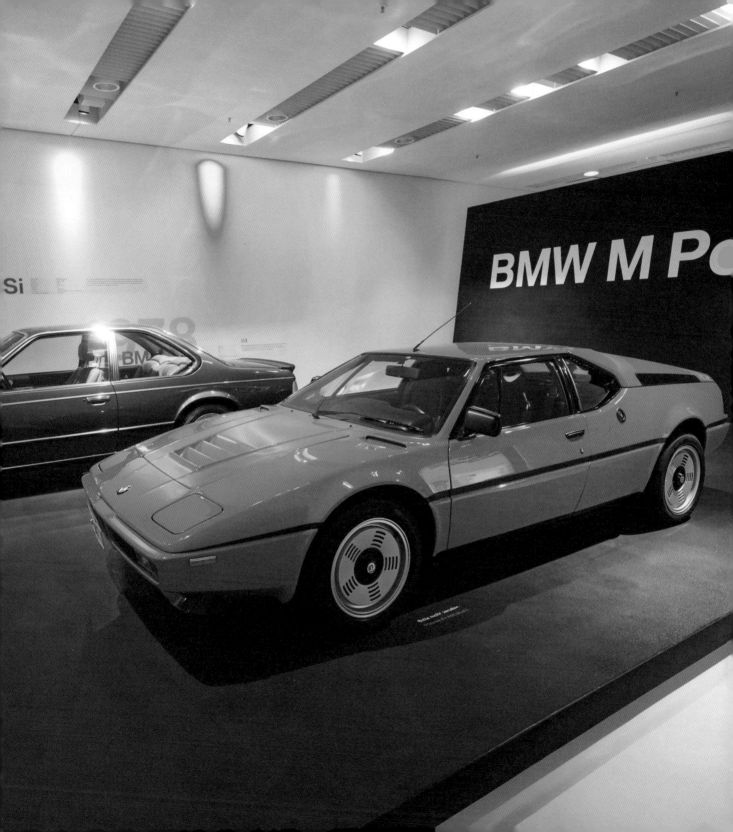

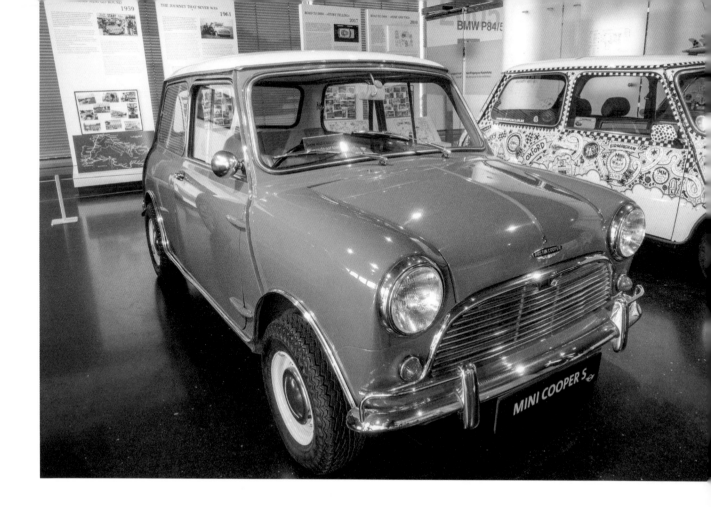

The display of many of BMW's pre-war aero engines is also fascinating, not least because this is where BMW started. Here is a 132 air-cooled radial engine from 1933 (opposite, above). That also got me thinking. In 1944, two BMW engines, basically the same but larger, powered a Dornier bomber flying just above tree height over eastern England. It was machine-gunning everything in sight. My grandmother pulled my baby carriage in through the front door just in time. The bullet scars can still be seen on the walls of my childhood home.

And then I saw a BMW E39 5 Series, the model that had saved the life of my three children and myself.

It takes a museum as good as this one to make you realize that, sometimes, things are more connected than you had ever thought.

Above: 1964 Austin Mini Cooper in the BMW Car Museum. Opposite, above: Air-cooled radial engine from 1933. Opposite, below: The 1928 BMW Dixi 3/15.

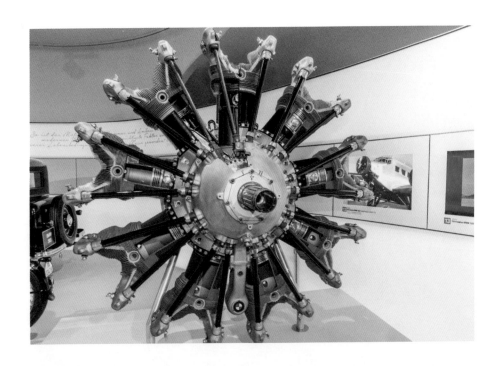

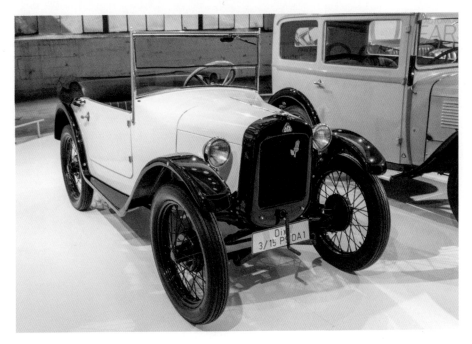

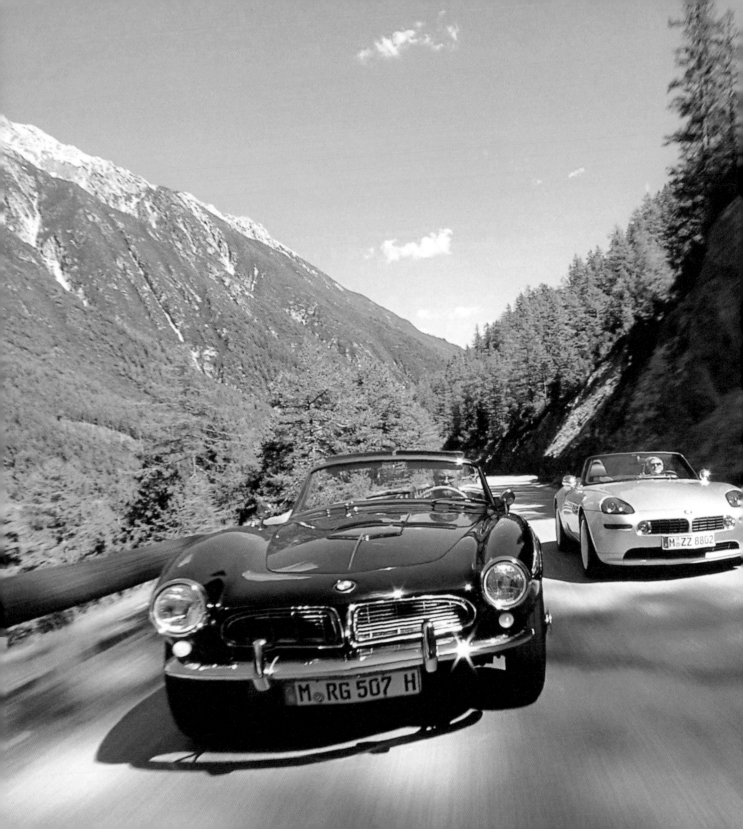

50

SHOULD YOU BUY ONE ... OR TWO?

If you want the highest performing car that is easy to drive, a BMW has to be for you. The downside? A lot of others think so too. Is there a suburban street anywhere without a BMW on the driveway? BMW's stonking mass-production success since the 1980s now means you will never be alone.

You could buy an M, an Alpina or even an AC Schnitzer, but it will cost and only those in the know will know.

In any case, where are you going to let cars like that off the leash and keep your licence? A test-track, I guess.

Myself, I'd go for a silver 1999 Z8 and, to keep it company, a 1956 507. Just like Elvis's, but in black. I could then rock and roll those Alpine passes whenever I felt like it.

And that is one of the 50 reasons why I love BMW.

1956 BMW 507
with a 2000 Z8 in
the mountains.

ABOUT THE AUTHOR

Vaughan Grylls is an artist and writer. He lives in London and East Kent and has been a BMW enthusiast ever since he took delivery of an orange 2002ii in 1976. He has since owned five more BMWs. His favourite is a fourth-generation E39 530d Touring designed by Joji Nagashima.

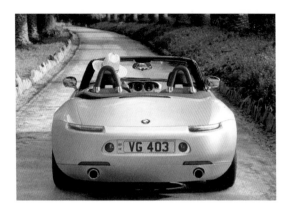

ACKNOWLEDGEMENTS

This book would not have been possible without Jeff Heywood, Vice President of the BMW Car Club GB, for his valuable comments and advice on the technical aspects and history of BMW, Susanna Small at Batsford Books for sourcing many of the images and Ferdy Carabott for resuscitating some ancient yet key ones. Last but not least, huge thanks to my editor Nicola Newman, for keeping this book on the road.

INDEX

First published in the
United Kingdom
in 2023 by
B. T. Batsford Ltd
43 Great Ormond Street
London
WC1N 3HZ

An imprint of B. T. Batsford
Holdings Limited

ISBN 978 1 84994 803 6

A CIP catalogue record for this book
is available from the British Library.

10 9 8 7 6 5 4 3 2 1

Reproduction by
Rival Colour Ltd, UK
Printed and bound by Toppan
Leefung Ltd, China

This book can be ordered direct
from the publisher at www.batsford.
com, or try your local bookshop.

PICTURE CREDITS

2 Klaus Ohlenschlaeger/Alamy; 7 The Advertising Archives; 8 ullstein bild Dtl. / Getty Images; 9 Zoonar GmbH/Alamy; 12–13 Jon D/Alamy; 13 John Keates/Alamy; 15 top, 44, 79, 84–85 Matthew Richardson/Alamy; 15 bottom Motoring Picture Library/Alamy; 16 top, 24–25, 34–35, 68–69 ZarkePix/Alamy; 16 bottom MediaWorldImages/Alamy; 16–17 bottom Roman Belogorodov/Alamy; 19 top, 16–17 bottom, 19 top and bottom Roman Belogorodov/Alamy; 20 top Karl Allen Lugmayer/Alamy; 20 bottom, 48, 64, 98, 112 dpa picture alliance/Alamy; 22, 116–117 Andre Jenny/Alamy; 23 Classic-Ads/Alamy; 26–27, 28–29 top, 32–33 Grzegorz Czapski/Alamy; 28 bottom, 106 left Phil Talbot/Alamy; 30–31 Emirhan Karamuk/Alamy; 36–37 top, 76 top, 80–81, 90–91 top Goddard Automotive/Alamy; 37 top Aleksandr Zavatskiy/Alamy; 38–39 VDWI Automotive/Alamy; 40–41, 90 bottom, 108–109 bottom left Mariusz Burcz; 42–43 VDWI Automotive/Alamy; 45 Stephen Chung/Alamy; 46 top Roman Stetsyk/Alamy; 46 bottom VDWI Automotive/Alamy; 49 top and bottom Ray Evans/Alamy; 52–53 WENN Rights Ltd/Alamy; 54, 114–115 Zuma Press, Inc/Alamy; 55, 124–125 culture-images GmbH/Alamy; 58–59 Kertu Saarits/Alamy; 60–61, 75 bottom left, 123 top mauritius images GmbH/Alamy; 62, 63 © BMW; 66 top Media Drum World/Alamy; 66 bottom, 86 top, 86 bottom Oldtimer/Alamy; 70 REUTERS/Alamy; 71, 104–105, 106–107, 110 imageBROKER/Alamy; 72 Pixsell photo & video agency/Alamy; 75 top Randy Duchaine/Alamy; 75 bottom right, 97 Volodymyr Kalyniuk/Alamy; 78 VDWI Automotive/Alamy; 80 Ann Steward/Alamy; 82–83 Eugene Sergeev/Alamy; 85 Vladimir Volovodov/Alamy; 88 Howard Sayer/Alamy; 88–89 Dale Drinnon/Alamy; 89 top Carl DeAbreu/Alamy; 89 bottom Panther Media GmbH/Alamy; 92–93 MihAlex/Alamy; 94 top Tim Graham/Alamy; 94 bottom left Dinodia Photos/Alamy; 94 bottom right Derek Adams/Alamy; 96 left Shakeel Safeek/Alamy; 96 right Josef Kubes/Alamy; 99 claudio gedda/Alamy; 100–101 bigtunaonline/Alamy; 102–103 Mark Waugh/Alamy; 108–109 top left Drive Images/Alamy; 109 top right PATA/Alamy; 109 bottom right Heritage Image Partnership Ltd/Alamy; 111 Julian Eales/Alamy; 113 Gdefilip/Alamy; 114 Chris Yaxley/Alamy; 119 top Hemis/Alamy; 119 bottom Diego Grandi/Alamy; 120–121 Argus/Alamy; 122, 123 bottom Maurice Savage/Alamy. All reasonable efforts have been taken to ensure that the reproduction of the content in this book is done with the full consent of the copyright owners. If you are aware of unintentional omissions, please contact the company directly so that any necessary corrections may be made for future editions.